About the Authors

Mark Justice Hinton took his first photographs with an Instamatic around age 11, before graduating to his father's Agfa 35mm. For many years, Hinton shared a single-lens-reflex Nikkormat and a great macro-zoom with his wife, Merri Rudd. With the new century, Hinton (and Rudd) moved to digital photography with gusto, delighting especially in close-ups of flowers, bugs, and birds. His neighbors and friends have grown used to Hinton's ever-present camera.

Hinton is also a long-time computerist and author of *PC Magazine's Windows Vista Solutions* (published by Wiley). He has taught computer classes for the University of New Mexico for more than 20 years.

Barbara Obermeier is principal of Obermeier Design, a graphic design studio in Ventura, California. She's the author or co-author of more than sixteen publications, including *Photoshop Elements 7 For Dummies* and *Digital Photography Just the Steps For Dummies,* 2nd Edition (both from Wiley), and *How-to-Wow with Illustrator* (Peachpit Press). Barb also teaches Graphic Design at Brooks Institute and the University of California, Santa Barbara.

Dedication

To Merri Rudd, brilliant on both sides of the lens. —MJH

Authors' Acknowledgments

From a distance, a book appears to follow a straight line from writer to reader. Up close, one sees the web of other critical participants. A surprising number of editors turn raw into readable. Still more people make the book real and bring it to your hands. My thanks to everyone in the web of this book.

More specifically, I could not have done this book without Jodi Jensen, editor extraordinaire, whom I cannot thank enough. I am also grateful to Steve Hayes, Susan Christophersen, Chuck Pace, Leah Cameron, Amanda Foxworth, and Cherie Case.

I have lived with two great photographers. John Merck taught me to take lots of pictures and show only the best. (I'm still learning the second half of that lesson.) Merck also taught me the eponymous Merck Shot: a breathtaking close-up.

For more than 26 years, I've learned from Merri Rudd, who taught me to change my perspective in more ways than one. Merri let me use the same camera she had used as she crawled on her belly among mountain gorillas in the jungles of Rwanda. Her two shots were always better than my 34 on every roll. I owe her this book. (Not a valid contract.) —MJH

Publisher's Acknowledgments

We're proud of this book; please send us your comments through our online registration form located at http://dummies.custhelp.com. For other comments, please contact our Customer Care Department within the U.S. at 877-762-2974, outside the U.S. at 317-572-3993, or fax 317-572-4002.

Some of the people who helped bring this book to market include the following:

Acquisitions and Editorial

Project Editor: Jodi Jensen

Executive Editor: Steve Hayes

Copy Editor: Susan Christophersen

Technical Editor: Chuck Pace

Editorial Manager: Jodi Jensen

Editorial Assistant: Amanda Foxworth

Sr. Editorial Assistant: Cherie Case

Cartoons: Rich Tennant
(www.the5thwave.com)

Composition Services

Project Coordinator: Kristie Rees

Layout and Graphics: Stacie Brooks, Carl Byers, Jennifer Mayberry, Brent Savage

Proofreader: ConText Editorial Services, Caitie Kelly

Indexer: Broccoli Information Management

Special Help
Annie Sullivan

Publishing and Editorial for Technology Dummies

Richard Swadley, Vice President and Executive Group Publisher

Andy Cummings, Vice President and Publisher

Mary Bednarek, Executive Acquisitions Director

Mary C. Corder, Editorial Director

Publishing for Consumer Dummies

Diane Graves Steele, Vice President and Publisher

Composition Services

Gerry Fahey, Vice President of Production Services

Debbie Stailey, Director of Composition Services

Contents at a Glance

Table of Contents

Introduction

*S*mile! Everybody say "cheese."

Photographs freeze a moment in time forever. Even an under-exposed, out-of-focus photo may affect you as strongly as the finest photo art. Photographs fascinate and entertain. People like photos.

Whether you use a cell phone camera or a top-of-the-line profes-sional model, the widespread availability of digital cameras has energized popular photography. At any moment — triumphant or embarrassing — you can be ready to capture the scene.

Some things about photography haven't changed with digital technology. Your pictures have a subject and a frame. You can compose your photo by following guidelines that go back farther than anyone reading this book can remember. However, digital photography has brought a few radical changes to photography:

- Photos are immediately accessible and shareable — no more delayed gratification
- Photos last forever — digital never fades or curls
- Technology makes things easy that used to be impossible by enabling you to stop action and capture great details

The phrase *point and shoot* promises an ease of use that most digital cameras deliver. But this simplicity also brings new challenges, such as what to do with the 20,000 digital photos stashed on your hard drive.

Your camera's Automatic mode almost guarantees that you'll take adequate photos under most circumstances. That mode leaves some room for improvement in your shots, however. Your camera has more sophisticated modes and settings, and this book tells you what they are and how to use them.

After the shot has been captured, you can still do more with the photo. A few simple edits can transform a photo from

"okay" to "Wow!" You can share your snapshots or art with the world or with just a few friends.

About This Book

Taking good photographs does not require you to be exceptionally talented or studious. Neither should your photographs force your friends to yawn and make excuses to avoid looking at 300 similar shots from your vacation. The goal of this book is to help you enjoy taking pictures and to help you experiment with all the features of your camera, as well as to deal with your photos after the shot.

This book provides an overview that takes you from buying a camera to taking easy photos, to better photos, to sharing your photos. Along the way, we provide enough depth to help you gain confidence in your photographic endeavors. You won't find any long-winded lectures here ("Lens Caps: Impediment or Opportunity?"), but you will find helpful step-by-steps and friendly advice from folks with a lot of experience with digital cameras.

In this book, you discover

- ✔ What to look for in your next camera
- ✔ How to choose among camera settings
- ✔ How to move pictures to your computer
- ✔ How to make easy, effective edits
- ✔ How to share photos with friends through e-mail, the Web, and printing.

Whom This Book Is For

You may already have your first digital camera, or you may be ready to get a new one and are looking for some guidance on what type of digital camera to buy. Perhaps you want to take advantage of your camera's automatic functions, but you're curious about what else your camera can do. If you want to find out the essentials of digital photography — from choosing a camera to printing your photos, and all the steps in between — this book is for you.

How This Book Is Organized

The book is divided into five parts, and each part is divided into multiple chapters. Although we're happy to have you open this book at Chapter 1 and read it from cover to cover, it's organized so that you can quickly flip to any section of any chapter and find just the information you need right then. Here is how this book is laid out.

Part I: Getting Started the Digital Way

The two chapters in this part cover buying a digital camera and taking your first photos. In the first chapter, you discover the features to look for in a new camera. The second chapter presents suggestions for using your camera's preset scene modes to take your first photos.

Part II: Taking More Control

Start using more of your camera's features. Chapter 3 introduces controlling exposure for just the right brightness. Chapter 4 focuses on, well, *focus*, along with common guidelines for composing your photos. Chapter 5 discusses how to photograph special subjects from portraits, to animals, to events.

Part III: Managing and Editing Your Photos

The chapters in this part help you organize your photos and make them better through editing. Move your photos from the camera to your computer. Make some common and simple changes using any photo editor. And discover some of the fancier edits a powerful editor — Photoshop Elements — makes possible.

Part IV: Sharing Your Photos

These chapters show you how to e-mail your photos, publish them to the Web, and print them. Plus, we've tossed in some help with scanning old photos, as a bonus.

Part V: The Part of Tens

The book ends in classic *For Dummies* fashion with ten tips for getting better photos and ten reasons to check out the popular Flickr photo-sharing Web site and the free Adobe Photoshop Express online photo editing resource.

Icons Used in This Book

You may notice the little icons that appear in the left margin throughout the book. These are standard *For Dummies* road signs to give you some guidance along the way. They tell you, among other things, when to pay especially close attention, when to step lightly, and where to find additional information. Here's what they mean:

Look for this icon for something extra, some suggestion you can easily put into practice right away. These are the chocolate chips in the book's cookie.

Now and then, we want to remind you of something before we go on. We know you remember every word you read. We just want to be sure we didn't forget to mention something already.

When something pops up that could cause some trouble, such as "click Yes to delete all photos," we'll warn you about the consequences.

If we know of a good reference that covers a topic more completely than we can, we'll give you a heads-up about it with this symbol.

Where to Go from Here

Take a look at the Table of Contents or the index, and then flip pages and skip along to your delight. Or, you can work your way through the whole book, one page at a time. After all, it's your book.

Please visit Mark's companion Web site for this book at www.mjhinton.com/DCPFD to ask questions, suggest topics for future editions, or comment on the book.

Part I
Getting Started
the Digital Way

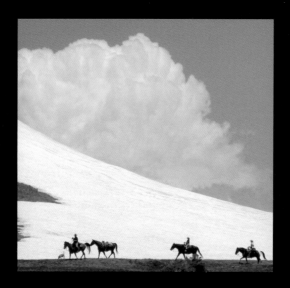

In this part . . .

*D*igital cameras come in a range of sizes and capabilities. A pocket-sized, fully automatic camera is convenient but has some limitations on the features you can control. A mammoth professional model is versatile, but it comes with a higher price tag. In this part, we introduce you to the basics of digital cameras and help you sort out the details so that you can determine what features matter most to you.

Then, with camera in hand and some help from Chapter 2, you can jump right into taking pictures.

1

Choosing and Using Your Camera

*C*hoosing a digital camera is like choosing any other technical device, such as a computer or a car. You can carefully weigh multiple criteria, or you can buy the blue one or the used one. As is true of any device, cameras have features that are more or less important, although people will disagree about the level of importance.

In this chapter, you focus on camera hardware. (You knew we had to get that pun out of the way.) Whether you're shopping or already have a camera, we encourage you to start with the broad categories and work your way down to the details of the accessories.

Determining What You Need

Before you think about the specific features of a digital camera, consider how you expect to use it. Will you carry

it everywhere? Are you after snapshots? Do you want to create art?

What do you expect to do with your photos? Will you e-mail them, post them on the Web, or print them? If you print, do you want postcard-sized or poster-sized prints?

Before you start looking at cameras, ask yourself these important questions to determine your needs:

1. What is most important to me: portability (which means small, like the camera shown in Figure 1-1) or a camera that is feature rich?

Figure 1-1: Portability might be an important consideration.

2. How much money is in my budget?

3. How often will I use my camera? Will I take occasional family photos or become a proficient amateur photographer?

4. What kind of photography interests me? Will I shoot mostly landscapes and portraits, or do I want to be able to capture my child's soccer games and other fast-moving subjects?

5. What kind of lighting will I typically work with — outdoors, indoors, or both? What about weather conditions?

6. Will I print photos, and will I want to print large photos?

7. Will my existing equipment be compatible with the new equipment I'm considering?

8. Am I willing to learn a little about photography so that I can use different camera modes?

If possible, try out a camera before plunking down your hard-earned dollars. Some camera stores rent cameras for a daily fee. If you can borrow one from a friend or family member who happens to have a digital camera you're interested in, that's all the better. Also, be sure to talk to people who have digital cameras and read reviews in magazines and on Web sites such as www.dpreview.com.

Picking Out a Camera Type

With digital cameras (just *cameras* from here on), size matters. Small cameras that fit easily into your pocket are generally cheaper than big ones but usually have fewer features. Cameras with the most features are bigger and come at a bigger price. The in-between group is the *prosumer* category that straddles a line between consumers and professionals (I guess *confessionals* didn't sound high-tech enough). The prosumer models also fall between the other two groups in size and weight.

You may want a compact camera that is easy to carry and that you can pull out of your pocket for impromptu snapshots. Smaller cameras usually don't have a wide range of focus. So keep in mind that you may not be able to capture details from far away or extremely close up. In turn, fewer features generally make a camera easier to use.

The prosumer models typically cover a wide range from very close (*macro*, short for *macroscopic*) to far (zoom to ultrazoom).

The professional models are usually digital single-lens reflex (DSLR) cameras, based on the same design as that used for professional film cameras. In contrast to the fixed lens found on a *point-and-shoot* digital camera, you can change the lenses on a DSLR to suit the situation. You might switch to a macro lens for a close-up, and then switch to a telephoto lens for a distant shot.

Table 1-1 shows a comparison of the three main styles of digital cameras.

Table 1-1		Comparing Camera Types
Style	*Cost*	*Description*
Compact	$125 to $300	Easily slips into a pocket or small purse. Uses fixed lens and internal flash. Strictly auto-functional. Some models have image stabilization for sharper focus. Good ultracompact cameras are now entering the market.
Prosumer	$300 to $600	Has much of the power of a DSLR with the convenience of a point-and-shoot compact model. Usually has a fixed, high-range zoom lens. You can select manual or multiple automatic modes.
DSLR	$600 to $5,000	Aimed for serious hobbyists and professional photographers. Extensive interchangeable lens and external flash options.

Figure 1-2 shows the type of DSLR camera that a professional photographer might use.

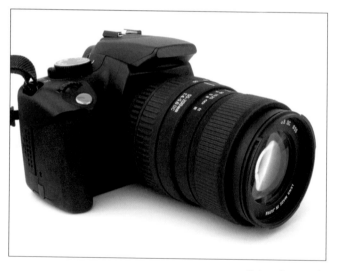

Photo credit: www.sxc.hu

Figure 1-2: A DSLR with zoom lens.

Examining Camera Features

Some camera features are universal, whereas others vary with the manufacturer. For example, every camera has a button you press to snap the shot (the shutter release). Where that shutter button is located and how hard you press it will vary from one camera to the next.

Every camera has the following core features:

- **The lens focuses the scene.** The lens is either plastic or glass; also, it may be immobile or may extend from the camera body when you turn the camera on or adjust focus.

- **The lens cover protects the lens.** The cover may slide automatically or detach manually as a lens cap. (Don't lose it.)

- **The shutter release button often has two steps.** Press partly to set the focus and fully to take the picture. Smile. Click!

- **The view finder (VF) shows you what the picture may look like, although the full area of the picture may be more or less than what you see in the VF.** The view finder may be optical or electronic (EVF). An EVF displays useful information as you focus but may be hard to see in bright light.

- **A liquid crystal display (LCD) shows the picture before and after you take it.** Some cameras have only an LCD or a VF — not both. A large, bright LCD helps you compose and review pictures but also consumes lots of battery power.

- **An image processor does just that: processes the incoming image into a stored file.** The image processor is likely to be a charge-coupled device (CCD) or complementary metal-oxide semiconductor (CMOS). Either technology is satisfactory for most photographers.

- **Batteries power all the camera functions.** Some cameras require a special battery; some use generic batteries.

Buy and carry extra batteries. If you want your photographic endeavors to be a little greener, use rechargeables.

✔ **A storage or memory card holds your pictures.** Most cameras have built-in storage, but that is surely too limited. See the "Removable memory cards" section, later in this chapter, for more about storage.

✔ **All but the most basic cameras also have a flash.** Some flashes pop up or out automatically; some are controlled manually.

Image size and storage

Digital images are made up of dots (*pixels,* which is short for *picture elements*). More pixels in an image mean more dots. These dots are bits of information, such as color and brightness, about each spot in the larger image.

Each picture you take is stored in the camera as a file. Bigger files store more information, increasing your editing and printing options. Three features combine to determine just how many pictures you can store in your camera: the type of memory card on which you are storing your photos; the file format in which your camera stores your photos; and the resolution of your images. We discuss these three features in the following sections.

Removable memory cards

The more gigabytes your memory card holds, the more pictures you can store on it. The type of card you use is determined by your camera; however, you can probably buy versions of the card type your camera requires in various storage capacities (more or fewer gigabytes). Table 1-2 shows a comparison of card types. (A *gigabyte*, which the numbers in the middle column refer to, is equal to one billion bytes.)

Table 1-2	Types of Memory Cards	
Media	*Gigabytes*	*Description*
CompactFlash (CF) card	1, 2, 4, 8, 16	Largest in apparent size (not necessarily storage size) and the oldest card type still in widespread use

Media	Gigabytes	Description
Secure Digital (SD) card	1, 2, 4, 8	More compact than CF; most common mini and micro sizes used in other, smaller devices
Secure Digital High Capacity (SDHC)	4, 8, 16	Newer version of SD card
XD picture	1, 2	Newest and smallest card type used primarily by Olympus and Sony
Memory Stick Pro card	1, 2, 4, 8	Used with Sony cameras and Sony devices; Pro (greater capacity), Duo (small form), and Pro Duo (more capacity in a smaller package) versions are also in use

The media shown in Table 1-2 are available in various speeds. Slower-speed media cards are substantially less expensive than newer, faster cards but can affect camera performance. The slower the card, the longer it takes the camera to read and write to the card. Card speed affects how many photos you can take per second. Most cameras also record video, and card speed may affect the frames per second (fps) for video. (Lower fps results in jerkier video.) However, don't buy a faster or higher-capacity card without determining whether your camera can take advantage of it.

Figure 1-3 shows a CompactFlash card, which is still used in many types of cameras.

As an alternative to saving your photos to a memory card, you can save a limited number of photos directly to your camera's built-in memory. Then, you can use the cable that came with your camera to transfer the images directly to your PC. However, this severely limits how many pictures you can take before you have to move them to your computer. Insert a compatible memory card, and your camera uses it automatically. For more information about transferring photos to your PC, see Chapter 6.

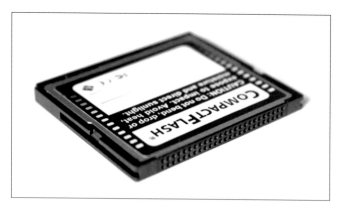

Photo credit: www.sxc.hu

Figure 1-3: CompactFlash is a common type of storage card.

File formats

You need to know how big each photo is before you know how many photos you can save per gigabyte. Digital cameras store photos in various file formats that use file extensions such as .jpg and .tif. Some formats produce larger files, which take up more space on your memory card, whereas other formats actually compress the image data so that it takes up less space. Compressing image data often involves throwing out some unnecessary data. Don't worry about some "tossed" data. The process is mathematical and well calculated. For most pictures, a little compression is worth the reduced file size. A picture that is too compressed and has lost too much data looks jagged or *pixilated* (spotty). A larger picture takes more storage space and more time to save and copy.

The available formats are determined by the camera manufacturer. Use your camera's setup menus to select the file format you want to use. For printing and editing, pick an available file format that compresses the pictures the least, but bear in mind that fewer photos will fit on your card. Table 1-3 explains the features of common formats from smallest to largest file size.

Table 1-3	Digital Camera File Formats
Format	*Features*
Joint Photographic Experts Group (JPEG or JPG)	The most common format, JPEG compresses files, losing some data in the process (called "lossy"). You may be able to adjust the compression (higher equals smaller size but lower quality; lower equals larger size and better quality).
RAW (not an acronym but written in caps)	RAW files contain extra information or multiple versions of an image, which some photo-editing programs use for advanced editing tasks. These files are the largest.
Tagged Image File Format (TIFF or TIF)	This uncompressed format produces large files and is commonly used for scanning and for some graphics programs because the image quality is high.
Audio-Video Interleaving (AVI)	A format commonly used for recording video.

If you get to choose from among JPEG, TIF, and RAW, choose RAW to have the most editing options with the right tools. If you use JPEG, choose the least-compressed option available. JPEG is the format generally used for sending images via e-mail or posting images on the Web.

Image resolution

Recall that a pixel is a dot of information about color and brightness. Your computer screen may be 1,024 pixels wide by 768 pixels high — 786,432 pixels in area. Consider an image that is 800 pixels wide and 600 pixels high (480,000 pixels in area). That image doesn't quite fill your screen. Printed on the average personal computer printer, this hypothetical photo is a little bigger than a postcard.

If that photo were 1,024 by 768 pixels, it would fill your screen and print larger. The area of that photo would be 786,432 pixels or .78 *megapixels* (MP — millions of pixels).

If you want a bigger photo on-screen or on paper, you need more pixels. You also want more pixels if you intend to *crop* a photo to eliminate some of the outer portions of the image and show just part of the photo. The maximum number of pixels per photo is a camera's *resolution*. The more pixels in an image, the bigger you can print the image. You set the image resolution through your camera's setup menus up to the maximum the camera supports.

Spend some time exploring your camera's menus and documentation. Look for reviews on the Web that describe and critique these menus so that you have a better understanding of how to get the most out of your camera.

Figure 1-4 shows two versions of the same image. The bigger image looks good. Enlarging this photo, from the smaller size shown in the top-left corner, didn't affect this photo's quality. Printed even larger, however, the quality may begin to degrade. A photo's resolution limits its maximum print size. If you try to print an image larger than the maximum size suggested for that resolution, the print may lose substantial quality and be unacceptable.

Table 1-4 shows some of the available image resolutions for digital cameras.

Table 1-4	Available Image Resolutions	
Number of Megapixels	**Image Size in Pixel Dimensions***	**Approximate Acceptable Print Size at 300 dots per inch (dpi)**
2	1600 x 1200	4 x 6
3	2048 x 1536	5 x 7
4	2464 x 1632	5 x 8
6	3008 x 2000	7 x 10

Number of Megapixels	Image Size in Pixel Dimensions*	Approximate Acceptable Print Size at 300 dots per inch (dpi)
8	3264 x 2448	8 x 11
10	3872 x 2592	9 x 13
12	4290 x 2800	9 x 14
16	4920 x 3264	10 x 16

** Pixel dimensions may vary depending on the camera model.*

The ideal resolution for you depends on what you plan to do with the photo. Most of the photos displayed on Web sites are 1,024 by 768 pixels or smaller — less than 1 MP. An e-mailed photo might be even smaller. If you'll never print that photo at all — or at least never larger than at the standard print size of 4 x 6 inches — isn't 2 MP enough?

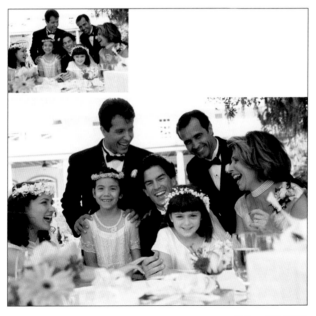

Photo credit: Purestock

Figure 1-4: Differences in resolution affect the size of good-quality prints.

To answer that question, consider whether you might want to occasionally crop photos to draw attention to a detail from a larger photo. The more megapixels you have, the smaller the portion of the original you can crop to and still have something to see and print. So, even if you never expect to print at 10 x 16 inches, having a 16 MP camera means that you can print at that size if you want, and it gives you the capability to crop your photo down to a tiny area and still have a decent-sized image. When you start editing your photos, the more pixels, the better.

There is a negative side to lots of megapixels: the resulting file size is larger, taking more space on the memory card or on your hard drive and creating bigger attachments to e-mail, as well as making files slower to copy. This is why your camera's setup menus allow you to choose lower resolutions if you want to store more pictures per memory card.

So, resolution, memory card type, and file format collectively determine how many photos you can take before you have to move or delete some.

For the greatest flexibility, buy a camera with high resolution. Set the resolution to the max. Buy the largest memory card the camera supports. Choose the format that stores the most information (biggest files).

See Chapters 7 and 8 to find out about editing your photos, Chapter 9 for information on sending your photos through e-mail and posting them to the Web, and Chapter 10 for help with printing your photos.

Exposure settings or modes

There is more to taking a picture than pointing and shooting. In addition to a fully automatic mode that controls everything, most consumer and prosumer cameras feature *modes* that automatically set the camera for certain conditions. These modes may be called *scene modes*, as well. Look for symbols or letters that represent these modes.

Landscape mode sets the focus to infinity, for example; look for a mountain-like triangular symbol indicating this mode. Macro mode, signified by a flower symbol, sets the focus very, very close — even less than an inch. Sports mode takes very fast pictures to freeze the action. You may see a golfer or a

runner as the symbol for this mode, although a soccer player seems more appropriate. Night-time mode (look for a crescent moon or a star) adjusts for low light. Automatic mode makes all the choices for you and may be just right for many photos. The indicator for Automatic mode often appears as a green camera symbol.

The purpose of these scene modes is to make it easy to adjust the camera to different conditions. The camera settings required to photograph a tiny flower are different from those required for a mountain or a person running. Some newer cameras analyze the scene and choose scene modes automatically.

Beyond the preset scene modes, prosumer and DSLR cameras typically include the following less-automatic functions:

- **Aperture Priority (A):** You control the size of the lens opening (*aperture*); the camera adjusts the shutter speed. A bigger aperture lets in more light, which is best in low light conditions, but has a narrower *depth-of-field* (how deep an area is in focus). A smaller aperture lets in less light but has a deeper depth-of-field, which is best for a landscape on a bright day.

- **Shutter Priority (S):** Just the opposite of Aperture Priority: You control the speed of the shutter; the camera controls the aperture. Capturing action requires a faster/higher shutter speed. A slower shutter speed is appropriate for low light.

- **Manual (M):** You set both the aperture and the shutter speed. Manual control enables exquisite control over the exposure, but requires experience and experimentation.

Focus controls range from fully automatic, center focus, and multipoint focus to fully manual focus based on the distance to the object on which you're focusing.

You may find any of these additional controls on a camera:

- **View finder/LCD toggle:** Switches between an electronic view finder (EVF) and the larger LCD display, which is best for menus, macros, and reviewing your pictures.

- **Review or playback control:** Shows the pictures you've already taken on the LCD or EVF.

✔ **Flash control:** Turns the flash on or off and may also include a red-eye reduction flash (a pre-flash that causes your subjects' irises to contract to eliminate red-eye). See Chapter 7 for more on red-eye.

✔ **Self-timer:** Lets you jump into the picture before it's taken.

✔ **Image stabilization:** Reduces shakiness or blurring and is critical for zoomed photos.

✔ **Zoom lens:** Focuses over a range from near to far, letting you choose how close to get (as opposed to a telephoto lens, which is fixed at the far distance). A zoom lens lets you get closer to a distant subject and fill the frame. Zoom can be optical or digital (or both). Digital zoom automatically crops the photo, lowering the resolution of the picture. The quality of a digital zoom rarely matches optical zoom. Ignore digital zoom when comparing two cameras.

Zoom is measured in factors: 3x is three times closer than normal (for that camera); 10x is ten times closer.

A zoom of 10x or more is great for an outdoors photographer. The bigger the zoom (20x is the current extreme), however, the greater the odds of shakiness or blurriness. You need good image stabilization and a tripod or very bright light.

A rational person would assume a 12x camera zooms 20 percent farther or closer than a 10x camera. That is not necessarily so because the *x* refers to *normal* for that specific camera. If the 12x normal is a wider angle lens, the zoom might not be that much farther than the 10x. For this reason, technical specifications and reviews often convert zoom to film-camera 35 millimeter equivalents. (This is more familiar to film and DSLR photographers.)

✔ **Face or smile detection:** Go ahead, smile. Some cameras can focus automatically on faces. Newer technology can actually delay the exposure until everyone in the photo is smiling. There is no sincerity check.

✔ **Remote controls:** Rare, but handy for tripod mounted shots or for playback and slideshows.

Checking Out Other Hardware

This section looks into equipment beyond the basics included with most cameras. Some of this applies to any camera, such

as a camera bag, whereas other examples may be limited to particular cameras, such as an external flash or additional lenses, which apply largely to DSLR.

Accessories for all

There are a handful of accessories (literally) that any camera owner needs. Camera retailers are an obvious source for these items, but you can find some of these accessories in sporting goods stores, office supply stores, and thrift stores.

A camera bag protects your camera from bumps and drops. You may want a padded bag that just barely covers the camera, or you may want a bag that holds all your other goodies. If you carry your camera on a bicycle, you may want a handlebar bag.

A camera strap keeps your camera handy and declares, "I am a tourist or a camera geek!" A hipper option is a carabiner to hook your camera to your belt loop. (Be sure to test the heft of your belt loop.)

A tripod may seem to cross the line into excessive accessorizing, but the combination of tripod, image stabilization, and self-timer can produce the sharpest zoomed photos possible. A tripod is essential for night shots.

If your camera has a tripod mount — a metal screw hole in the bottom of the case — get a pocket-sized tripod or bean bag with tripod screw. A small tripod is very handy for impromptu self-portraits. It sure beats balancing the camera on a rock or fanny pack.

Table 1-5 lists some additional accessories to put high on your list.

Table 1-5	Camera Accessories
Accessory	*Comments*
Extra battery	A critical accessory. You can't have too many spare batteries.

(continued)

Table 1-5 *(continued)*

Accessory	Comments
Battery charger	Without batteries, a camera is a doorstop. Keep your spares fully charged. (Get an adapter for your car's cigarette lighter.)
Extra memory cards	After you fill your card, you need to move those pictures to your computer or swap in an empty card.
Image-editing software	Typically bundled by manufacturers or included with your computer operating system. Popular programs available for purchase include Adobe Photoshop, Adobe Photoshop Elements, Adobe Photoshop Lightroom, and Apple's Aperture. Free programs include IrfanView (for Windows) and iPhoto (for Mac).
Photo printer	Most color inkjet printers print a decent photo on regular paper. You can also use special photo paper or a printer specifically designed for printing camera images.

Your high-end wishlist

DSLR cameras and some other higher-end models allow for very sophisticated accessories. You need a much bigger bag for these.

Flash dance

An external flash provides more options for illuminating a scene. A *hot shoe* is the place on your camera body where you attach an auxiliary flash. A hot shoe enables the camera to trigger the external flash.

Flash specifications may include the range it can illuminate effectively, from near to far. Figure 1-5 shows a DSLR with an external flash mounted on top.

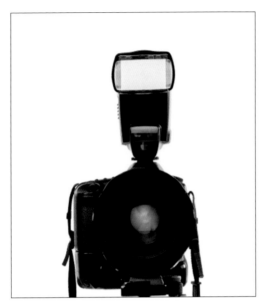

Photo credit: iStockphoto.com

Figure 1-5: A DSLR with an external flash.

Table 1-6 describes the different types of flash available. You can use flash in different modes, which are also listed in Table 1-6.

Table 1-6	Types of Flash and Flash Modes
Feature	*Description*
Internal flash	The flash type built into the camera body and found on non-DSLR cameras.
Pop-up flash	Pops up from the camera body, either automatically or at your control.
External flash	A prosumer/DSLR option that offers greater flash range and control. Attaches to a hot shoe connection.
Auto mode	Turns on flash when low light levels exist.

(continued)

Table 1-6 *(continued)*

Feature	Description
Fill or Force mode	Flash always fires. Useful for portraits, even in daylight, especially in harsh sunlight that causes deep shadows.
Red-eye reduction	Flash fires initially to close subject's irises before main flash fires and image is captured.

Lenses for every purpose

Whereas consumer and prosumer cameras have one lens, DSLRs allow you to swap lenses to suit the circumstances. A grand landscape might be grander with a wide-angle lens. You might want more than one long-range *telephoto* lens for different distant subjects. You can swap a zoom lens for a macro lens for extreme close ups. A fish-eye lens adds a comic effect. Figure 1-6 shows a few lenses.

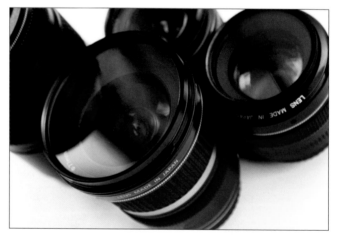

Photo credit: iStockphoto.com

Figure 1-6: Lenses are valuable accessories.

Some prosumer models accept an adapter ring that enables you to add another lens in front of the built-in lens. (These options are more limited than with a DSLR.)

Lenses fit specific camera bodies. Make sure you buy a lens that fits your camera, or vice versa. You may be able to find an adapter for lenses not designed for your camera body.

Table 1-7 shows common lens types. Lenses are measured in focal length, the distance in millimeters between the optical center of the lens and the image sensor that captures the image.

Table 1-7	Digital Camera Lenses	
Feature	**Focal Length**	**Comments**
Wide angle	14 to 35mm	A prosumer/DSLR lens that shoots a wide area in a tight space. May produce distortion.
Normal	28 to 50mm	A DSLR lens. For full-frame sensor cameras, 50mm is considered normal. For small-sensor cameras, such as Canon EOS or Nikon D series, 28 to 35mm is normal.
Telephoto	100 to 400mm or more	A prosumer/DSLR lens that shoots subjects at a distance.
Macro	N/A	A prosumer/DSLR lens that shoots subjects up close. On consumer cameras, select a mode for close-up shots.
Zoom	28 to 280mm (10x zoom)	Variable optical focal length, from wide angle to normal to telephoto. Non-DSLR cameras also zoom digitally; avoid digital zoom to preserve image quality.

Filters screw to the end of prosumer/DSLR lenses to protect the lens, filter out UV light (UV), reduce water or glass reflections (Polarizing), and more.

2

Fast and Easy Picture Taking

*W*ith camera in hand, you're ready to shoot. In this chapter, you learn enough to jump into using your camera with confidence. Before your first shot, set the image quality and get a sense of your camera's many automatic modes. Check out a few tips about light — photography is all about light and dark. And then take some fun shots before you review the photos on your camera's LCD.

Because of differences between camera makes and models, some setting names and locations may be different from what you find here. Be sure to have your camera's user manual handy, and remember that nothing beats getting out there and running your camera through its paces. Try every setting, take a shot, and see what happens. That's really the only way to truly feel comfortable with your camera.

Setting Image Quality

You want to take great photos, so make sure your camera is working with you. Set the image quality to yield the best photos and to give you maximum flexibility in editing and printing.

Image quality can be affected by two different settings: resolution and file format (both introduced in Chapter 1). For maximum flexibility after you've taken a photo, you want the highest resolution your camera is capable of, although that does produce the largest files. That means fewer photos will fit on your memory card. So you need to find a balance between resolution and file size. Use your camera's setup menu to see what options are available.

Figure 2-1 shows a sample Image Quality menu with quality options listed from highest to lowest (top to bottom) — and, in effect, file size from largest to smallest.

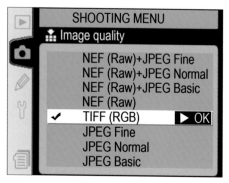

Figure 2-1: Choose a setting from the image quality menu.

You camera is likely to support the following three file formats:

✔ **JPEG/JPG:** This is the most widely used format for photographs. After all, JPEG originates with the Joint Photographic *Experts* Group. JPEG is designed to compress images in a very clever way by calculating what information you won't miss. JPEG compression varies by percentage, although most cameras don't specify a percentage. In Figure 2-1, notice the two options: JPEG Fine (which uses little or no compression) and JPEG Basic (which uses greater compression but probably still results in adequate

quality except for the highest grade and largest prints). In between the two in size and quality is JPEG Normal.

If file size isn't an issue, you want JPEG with the least compression. On the menu shown in Figure 2-1, for example, you would choose JPEG Fine.

✓ **TIFF/TIF:** This *tagged image file format* is an old format originally used for scanned images (discussed in Chapter 10). There are variations on TIFF, including some with compression, but it is usually a *lossless* file type — no data is removed during compression — and files are large, which results in higher-quality images but fewer photos per memory card.

✓ **RAW:** This is the newest format and can vary among cameras. The goal of RAW is to capture more information — everything the image sensor sees. RAW might include additional copies of the image with different exposures or formats, such as RAW + JPEG.

So, is RAW best and JPEG worst? Not necessarily. Remember that you will be viewing these pictures on your computer, attaching them to e-mail, uploading them to the Web, and editing them for hours. (Some people do. See Chapters 7 and 8 on photo editing.) Every program for working with or viewing photos handles JPEG easily. Only the latest software handles RAW. If you e-mail a huge RAW file to a friend, she may not be able to see it. JPEG gets points for longevity and ease of use, as well as smaller file size.

So, JPEG is best, right? Hold on. JPEG is lossy — JPEG compresses by throwing away data. If you repeatedly edit and save the same JPEG photo, you compress it more and more, eventually substantially degrading the quality.

For the record, Adobe, the maker of Photoshop and other photo editors, has created a RAW variant called Digital Negative (DNG). Microsoft has its own format, HD Photo. The question remains as to whether camera makers will adopt these formats.

On some cameras, you can shoot both RAW and JPEG simultaneously, thereby giving you more options in postprocessing. Just be sure to have plenty of large-capacity memory cards on hand.

Not to belabor this point, but for flexibility in editing and printing, you want the image resolution plus the file format

that together, not coincidentally, produce the largest files (because they contain more information). It's not that you want large files, but that you want the *benefits* of the information that makes those files larger. Complicating this issue is that large files take up more space (fewer photos per giga-byte), are slower to record to the memory card and to move around, and may not be as easy to work with as smaller files.

While you're rooting around in the setup menu, look for a sound option that controls the sounds the camera makes. A shutter sound may provide good feedback when you're shoot-ing, but it may also be disturbing, especially in a quiet setting. You may be able to turn the sound down or off.

Using Preset Scene Modes

Your camera probably has various scene modes that config-ure the camera for specific shooting conditions. Using these modes is easy and may produce better pictures — you just have to experiment.

Look for a mode dial, dedicated buttons, or menu options. Figure 2-2 shows a mode dial set to A for Automatic. Your camera may show Auto or a camera icon. The Automatic mode setting is usually the only green icon on the mode dial.

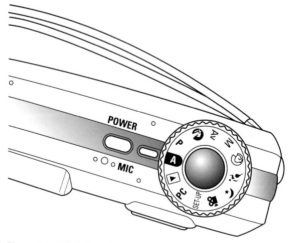

Figure 2-2: Pick from the preset scene modes.

Automatic mode does it all, of course. Don't be afraid to operate on Automatic. However, you will surely shoot in conditions in which other modes produce better pictures.

Landscape, Portrait, Night Sky, or Action/Sports modes may produce better pictures than Automatic under the corresponding circumstances.

 Take lots of pictures. Take the same picture several times, switching modes. See Chapter 3 to learn about Manual mode and other advanced settings.

The following steps guide you through taking your first photo. (You've already done this, haven't you?)

1. **Set the Mode dial or button to Automatic mode. In Automatic mode, your camera makes all the decisions.**

2. **Compose your shot in the viewfinder or LCD screen.**

3. **Press the shutter button halfway down to give your camera a moment to focus. This takes a fraction of a second, in most cases. You may see a green indicator on the LCD or electronic viewfinder (EVF).**

4. **Press the shutter button the rest of way to capture the image. (Writing the captured file to the memory card takes a fraction of a second — longer for bigger files.)**

5. **Switch to another scene mode and take the same picture. You can compare these versions later.**

 Play with different scene modes with the same subject. For more advice on using scene modes, see Chapter 4.

Shedding Some Light on Your Subject

Nothing is more important than light in photography. Or is darkness more important? In fact, a photo captures light and dark, as well as color. Photographers use numerous terms to describe the interplay of light and dark, such as exposure, contrast, and brightness.

Your camera's scene modes are preset for certain conditions of light and darkness. Start with the available light and consider the available modes. Eventually, you may want to add a separate light source (such as a flash) and delve deeper into your camera's controls.

Finding the light

Exposure refers to the amount of light that enters the lens. You can think about light in several ways, such as the direction, intensity (brightness), color, and *quality* of light. To incorporate these characteristics of light into your compositions, here are a few tips:

- **Time of day:** The best light for photographs is usually around dawn or dusk. The light is warmer and softer, and the shadows are longer and less harsh. Avoid midday light when the sun causes harsh or sharp shadows and squinting. If you must shoot at noon, move your subject into shady areas or turn your flash on to reduce shadows on faces. (This is called a *fill flash* or *forced flash*.)

 Turn every rule or suggestion upside down to see for yourself whether it's valid. Have a shootout at high noon. Where some see ugly shadows, you may capture something strong or dramatic. (Remember, no one has to see your mistakes.)

 When shooting indoors, try positioning your subject next to a window that doesn't have direct sunlight streaming through. You can also add light by using table lamps and overhead lights. Position the lights at a 45-degree angle to your subject, if possible.

- **Weather:** Cloudy or overcast days can be excellent for taking photos, especially portraits. The light is soft and diffused. An empty sky may be less interesting than one with clouds. Keep in mind that overcast days are especially useful for photographing people, as shown in Figure 2-3.

- **Direction:** Photographing a subject with *backlighting* (lighting that comes from behind) can produce a dramatic image, as shown in Figure 2-4. Avoid *lens flare* — those nasty light circles or rainbow effects that mar images — by not having your brightest light source shine directly into your lens.

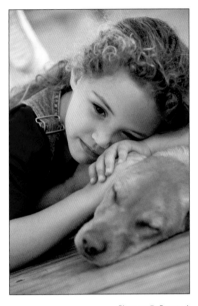

Photo credit: Purestock

Figure 2-3: Shoot in soft, outdoor light.

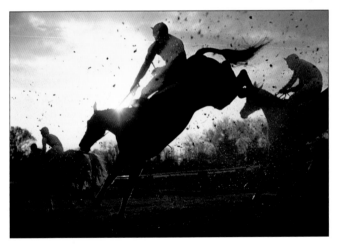

Photo credit: Digital Vision

Figure 2-4: Use backlighting creatively in an image.

Be careful shooting photos when the light source is directly behind your subject. Your camera may adjust the light meter to the lighter background and not to your subject, thereby creating an overly dark foreground or subject. If the exposure of the foreground subject is good, a bright background may be too bright in the photo. The effect is dramatic when intentional but awful when unintentional. Consider forcing the flash, if necessary.

✔ **Color:** The light at midday is white, the light at sunrise and sunset is orange and feels warm, and the light in shaded areas and at twilight is blue and appears cool.

Your camera's modes may *push* color in different directions in an effort to enhance the image.

✔ **Creative:** When possible, use lighting creatively to lead the eye, create a mood, or evoke an emotion. Look for compositions created with light illuminating or shadowing an object.

Using contrast

Contrast describes the degree of difference between light and dark areas. High contrast defines stark differences between light and dark areas; low contrast appears softer and more muted.

Mixing light with dark provides contrast, which in turns creates impact, as shown in Figure 2-5.

To highlight contrast in a photo composition, just be sure that the high-contrast area of your image is also the focal point, because that's where the eye looks first.

In color images, you can also achieve contrast by using complementary colors, such as red and green, yellow and blue, and cyan and orange. Look for contrast in both nature and your own setups.

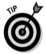

Even basic photo editors enable changes to brightness and contrast after the fact. A too-dark or too-bright photo may be repairable.

Photo credit: PhotoDisc

Figure 2-5: Contrasting light and dark creates impact.

Taking Some Fun Shots

Without delving any deeper into your camera's controls or photography's bigger picture (sorry, couldn't resist the pun), you can easily move beyond the standard snapshot (Although snapshots have their place, and not every picture needs to be art.)

You should look into (they're coming frequently now) changing your perspective. Get closer to a tiny subject with your macro setting. Bring a distant subject closer to you with zoom. Squat, crouch, stretch to put the lens higher or lower than standing height.

For every photograph you take, you always have an initial decision: whether to hold your camera horizontally (*landscape*, which is how it hangs from the straps) or to turn it vertically (*portrait*). That's a key decision, and you base it in large part on the shape of the scene: Do you want to include more vertical or horizontal area in the picture? Which perspective suits the subject? You might think portrait suits a person, but

what if the scene around them is important? Consider landscape in that case. (Take both.) You'd have to think landscape for a landscape — duh — but what if you want to lead the eye up a valley or along a ridge you're standing on? Try portrait to emphasize the depth or length. (Take both.)

One of the simplest edits is to *crop* a picture, which means that you save the part you want and throw the rest away. Cropped photos can be square or use other proportions than those of a standard print. See Chapter 7 for more about cropping and other types of editing.

Shooting close-ups in Macro mode

How close can you put your lens to an object and still take a clear photo? Many cameras have a separate Macro mode to enable you to photograph objects within inches — even less than an inch, for some. Look for a flower symbol on the camera body.

A macro exposure makes the small large — even huge. Figure 2-6 shows a close-up of a one-inch June bug on a chamisa bush. The original scene is barely two inches square, but it fills a computer monitor larger than life.

You may need to experiment with exposure settings. Start with Automatic or the Sports setting (for things that move fast, such as bugs or flowers in a breeze).

Don't use a flash with macros. A flash won't do any good that close and may ruin the shot. If your flash is set to Auto, you may have to suppress it (turn it off).

For flowers and small creatures, you may want to get on your knees or stomach for a good shot. A movable LCD can spare you that effort by flipping up or out.

The closer you get to the subject, the greater the odds that you'll actually bump into it or cast a shadow over the subject. Even a breath of air can move the subject and cause blurring. Consider placing the camera on the ground or a mini-tripod and using the self-timer.

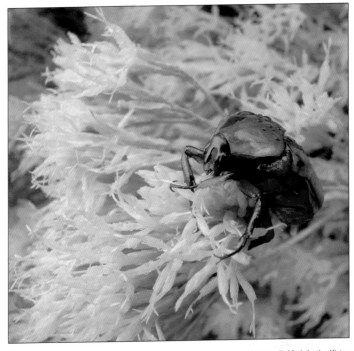

Photo credit: Mark Justice Hinton

Figure 2-6: Set your camera to Macro mode for close-up shots.

Check your camera's documentation to find out the particular focusing distance that Macro mode is capable of.

Follow these steps to take a macro exposure:

1. **Set the Mode dial or button to Macro on your camera. Look for a flower icon.**

2. **Compose your shot in the viewfinder or LCD screen. Focusing in Macro mode can be tricky, so be sure that the subject you want is in focus; if it's not, make the necessary adjustments.**

3. **Press the shutter button halfway to give your camera a moment to establish the shot.**

4. **Press the shutter button the rest of way to capture the image.**

Shooting from unexpected angles

To see the world differently, change the way you look at it. Get down (or up). Walk around your subject, if you can, crouching and stretching. Try not to frighten people in the process.

Take some photos from angles other than straight on at five to six feet off the ground — the world of the average snapshot. Changing your viewpoint can exaggerate the size of the subject either larger or smaller, enhance the mood of the shot, or make a dull shot more interesting, as shown in Figure 2-7.

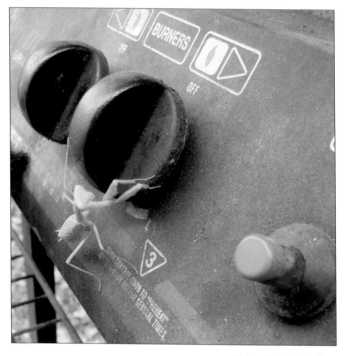

Photo credit: Mark Justice Hinton

Figure 2-7: Use an unexpected angle to exaggerate a subject. (Don't push the button!)

Depending on your particular subject, try a bird's-eye view (above the subject) or a worm's-eye view (below it).

Most flower photos are face on and nice enough. Try photographing flowers from the side or the back in the morning or evening (avoiding lens flare) — people seldom see this perspective.

Zooming in on your subject

Whereas a macro shot gets you closer to something that's already close by, a telephoto shot brings the distant object close to you. Strictly speaking, a *telephoto* lens has a fixed focal length. A *zoom* lens is a magical lens that easily ranges from normal to telephoto and every step in between. On your camera, look for a long switch labeled *W* (for wide angle — normal) at one end and *T* (telephoto) at the other (this kind of switch is called a *rocker*).

Gently press the *T* end of this odd switch while looking through the viewfinder or LCD. Zoom. With your eye glued to the camera, press the *W* end. Zoom back. An electronic viewfinder or LCD may display the degree of zoom or magnification from 1x (normal) to the maximum for your camera (10x is 10 times closer than normal; 20x is the current maximum).

Follow these steps to zoom:

1. **Focus on your subject and press the Zoom button until you achieve the framing you want.**

2. **Compose your shot and press the shutter button.**

3. **If your camera has an image-stabilization feature (often a waving hand), be sure that it's activated to help eliminate camera shake and the resulting image blur. (Automatic mode probably turns image stabilization on.) A tripod is helpful with a long zoom, especially in less bright conditions.**

 Some DSLR manufacturers recommend turning off image-stabilization (IS) if you are using a tripod. IS compensates for small movements; it may misbehave when there are no small movements to compensate for (as is the case when you use a tripod). Check your camera documentation. (Don't bother tapping the tripod to introduce vibrations to keep the IS happy.)

Keep in mind that zooming in with an optical zoom shortens the depth of field (DOF). An *optical* lens uses the optics of the camera (the lens) to bring the subject closer. (Chapter 3 discusses DOF in depth. Ahem.) Objects outside the DOF — nearer or farther — will be out of focus; the background may become blurrier, as shown in the close-up of a coreopsis flower in front of a green lawn in Figure 2-8. Make sure that this effect is what you want. This out-of-focus effect is called *bokeh*, from a Japanese word meaning *blurry* or *fuzzy*.

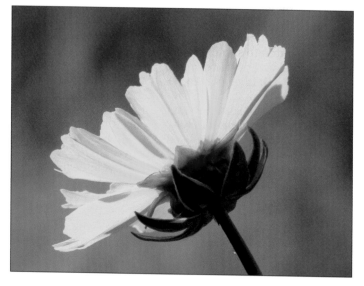

Photo credit: Mark Justice Hinton

Figure 2-8: Zoom in to your image.

Lenses with optical zooms are *real* zoom lenses. The lens actually brings the subject closer. A *digital* zoom isn't actually a zoom lens. It simply enlarges the center of the scene in the camera and crops out the rest. And a digital zoom can degrade image resolution and quality. If quality is paramount, you want to avoid using a digital zoom. You may have to disable the digital zoom by using a menu option or avoid pressing the zoom past the optical maximum setting.

There are three ways to fill a frame with your subject. One is to zoom in from a distance until it fills the frame. Another is to get as close as possible, using Macro mode, if necessary. The

third is to crop the subject out of a larger frame. You should try taking the same picture all three ways to get a better feel for the impact of your choice on exposure, background, and focus.

Holding Hollywood in your hands

Most digital cameras take movies, too. Look for a symbol that looks like a piece of film with sprocket holes down both sides, an old school reel-to-reel camera icon, or a box camera on a tripod.

With the dial set to Movie mode, press and release the shutter button to start recording a movie. You'll see a Record indicator on the EVF or LCD — look for a red circle or REC. The movie will continue to record until you press the shutter button a second time (or, until the disk fills or a fixed file size limit is reached). Some cameras allow you to pause and resume the same movie; most cameras create separate movies each time you start and stop.

Some cameras record sound with movies. Some cameras allow you to zoom in and out while making a movie. You just need to experiment to see what you can do with yours.

Your camera's setup menu may have a setting for frames per second (fps) — 30 fps or more is smoothest. You may also be able to choose a movie size or resolution — 640 by 480 pixels or greater is good.

An unsteady movie may nauseate your audience. Most movies taken with a digital still camera should be pretty short (up to 5 minutes) without too much walking around. A tripod will make movies steadier.

Typically, movie files are stored as AVI or MOV (QuickTime) files. These files are huge.

For an example of a movie, see Figure . . . wait, that's not going to work. Check out www.mjhinton.com/DCPFD for a short movie of hummingbirds around a feeder in Colorado.

If you're really serious about great movie making, you probably want a digital video camera and good movie editing software. For more information, see *Digital Video For Dummies*, 4th Edition, by Keith Underdahl (published by Wiley).

Reviewing Photos on Your Camera

You may want to see — and show — the pictures you've taken while they're still in your camera. That's instant gratification. Last century, people mailed film to a lab and waited weeks for their photos to come back on shiny bits of paper! A common reaction then was, "Why did I take that?"

If your camera has both an electronic viewfinder and an LCD, you can see your photos on either. The LCD will be better, of course, but remember that your batteries are draining.

Some cameras automatically show the most recent picture you took for a few seconds. You may be able to turn that feature on or off in the setup menus. (It can be distracting if you quickly shoot several pictures in a row.)

To review photos, look for the one button you haven't used so far, which may have a triangle on it. In Review mode, other buttons change function to enable you to move forward and back or, possibly, to see more than one photo at one time. Zoom may even zoom into the picture.

Don't bother to delete or edit photos on the camera. Move them to your computer, instead. Chapter 6 shows you how.

Some cameras can connect to TVs using standard RCA or USB cables, allowing you to run a slide show on the TV. (That's a great time to have a wireless remote.) You probably don't want to show every picture on your memory card, though. Chapter 9 shows you how to create CD and DVD slide shows.

Part II
Taking More Control

The 5th Wave · By Rich Tennant

©RICHTENNANT

"Well, well! Guess who just lost 9 pixels?"

In this part . . .

Some see photography as the inter-section of science and art. Lofty sentiment aside, both technology and technique are at play when you take a picture, and knowing even just a little about both can make for better pictures and more fun taking them.

You can find out more about the science behind photography in Chapters 3 and 4. (The test is multiple choice.) Chapter 5 delves into the art of photographing different types of subjects, such as people and animals, and various types of settings. (Just kidding about the test, by the way.)

Getting the Right Exposure

· ·

· ·

*L*ook off at a spot exactly four feet in front of your face. (Okay, look around first to make sure no one is watching.) How hard is that? Now, using your eyes — not your camera — make everything five feet away blurry. Can't do it? Cameras can do that: focus precisely and vary the depth of field (DOF) — really the depth of *focus*, with blurring nearer and farther than the DOF.

The point is, the lens isn't really just an extension of your eye. Cameras and eyes (plus brains) have very different optics and follow different rules. You don't have to master camera optics, but you need to be aware that certain factors can affect what you get out of your camera.

This chapter can help you move out of the preset scene modes into various manual options. You start to juggle settings that the scene modes handle automatically for you.

To take great photos, your best approach is to learn the rules and guidelines first — and then break any you choose. Experimenting is totally safe, as you find out in Chapter 6, where I show you how to delete the evidence of your rebelliousness,

and in Chapter 7, where you see how to edit those less-than-perfect photographs.

For now, your most important task is to get to know your camera. Become familiar with how your camera works as you become more comfortable with the fundamentals of photography. Remember that you have no film to process, so get out there and push those buttons.

Understanding Exposure

Exposure refers to the amount of light allowed to fall on the image sensor in the camera during image capture. Exposure is the result of the combination of the length of time that the image sensor receives light (*shutter speed*), the size of the lens opening (*aperture*), and the light sensitivity of your image sensor. The next few sections tell you more about each of these settings.

Figure 3-1 shows the physical relationship of four hardware components. Light passes through the lens. The amount of light that enters the camera beyond the lens is controlled by the aperture. How long that aperture admits light is controlled by the shutter. Whatever light the aperture and shutter let in strikes the image sensor, whose sensitivity to that amount of light is modifiable. The image sensor translates light into digital information that is then written to your memory card.

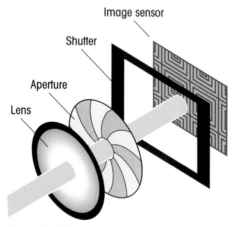

Image sensor

Shutter

Aperture

Lens

Figure 3-1: Light passes through the lens, aperture, and shutter to strike the image sensor.

Figure 3-2 represents the range between darker and lighter exposure. Each setting listed individually in the figure pushes exposure lighter or darker.

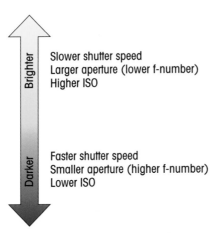

Brighter

Slower shutter speed
Larger aperture (lower f-number)
Higher ISO

Darker

Faster shutter speed
Smaller aperture (higher f-number)
Lower ISO

Figure 3-2: Changing one setting changes exposure.

If you change just one of the three settings I just mentioned — say, shutter speed — you change the exposure. Increased shutter speed decreases exposure. That's ideal if the scene is very bright, but it's not so good if the light is dim because there isn't enough time for the exposure. *Underexposure* translates into a darker image. Decreased shutter speed increases exposure, which is good for low light but washes out a photo in bright light. *Overexposure* translates into a lighter image.

Figure 3-3 shows an overexposed image and Figure 3-4 shows an image that is underexposed.

People react to photographs. Light affects mood and emotion. A bright scene may be uplifting; a dark scene may evoke somberness or look strikingly dramatic.

As you see in each of the following sections, your camera lets you control one variable while it adjusts the others. In terms of Figure 3-2, as you push a setting in one direction, the camera will push another setting in the other direction to try for balanced exposure. Manual mode enables you to change more than one setting and to choose a combination the camera might not choose. (Results can be good or bad, in that case.)

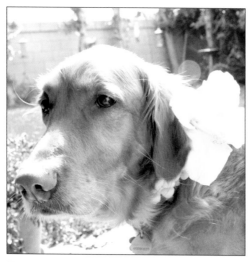

Figure 3-3: An overexposed image.

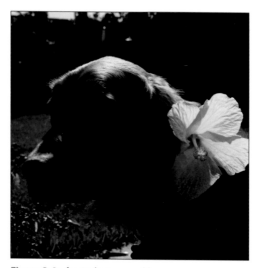

Figure 3-4: An underexposed image.

Setting the shutter speed

The shutter has to open for any exposure to take place. That's why your camera has a shutter button — to trigger the opening

of the shutter. How long the shutter remains open after you click that button is determined by the shutter speed setting. Outside on a sunny day, a faster shutter speed may be necessary to avoid overexposure. As the sun sets, you may want to use a slower shutter speed for the same level of exposure.

Shutter speeds are measured in fractions of seconds or whole seconds and usually range from 30 seconds to $\frac{1}{4000}$, or sometimes even $\frac{1}{8000}$, of a second. Some cameras also have a B (Bulb) mode, which enables you to keep the shutter open as long as you hold down the button.

Another consideration in setting shutter speed is whether anything in the scene is moving. When you're using slower shutter speeds and a stationary camera, objects in motion will blur. Higher shutter speeds freeze the action.

A camera's Sports mode automatically sets a higher shutter speed for action shots. Take advantage of that when photographing wildlife.

If your camera has Shutter Priority mode (most likely S or SP on the mode dial), use it to specify the shutter speed to use. In this mode, your camera automatically adjusts the aperture, which I discuss in the next section. When you choose a slower shutter speed, the exposure gets more time. Consequently, your camera automatically chooses a smaller aperture to admit less light for the exposure, avoiding overexposure. Conversely, choosing a faster shutter speed allows less time for the exposure, and your camera chooses a larger aperture to admit more light in the time available to avoid underexposure.

Keep the following in mind when you're setting shutter speed:

✒ Set the shutter speed by turning the dial located on the front or top of your camera and looking at the LCD display. On the Mode menu or dial, choose Shutter Priority mode, which may be labeled as S, SP, or Tv (as in *time value*). Setting your camera to Shutter Priority mode enables you to manually set the shutter speed while the camera determines all other settings. If you can't locate the dial, check your camera's user manual to see if your camera offers this mode.

✓ Look for an indicator in your EVF or on the LCD that confirms that the camera settings are within an approved programmed range. You may see a green light if the settings are acceptable or a red light if the settings are not acceptable.

✓ The brighter the scene, the faster the shutter speed you can use, such as ¼₀₀₀. For speeds slower than ⅟₆₀ of a second, you should use a tripod to avoid camera shake and to ensure a sharp image. If you don't have a tripod and your camera has an image-stabilization feature, be sure to turn it on for slower shutter speeds.

✓ Keep in mind that when you use Shutter Priority mode, the aperture adjusts automatically. So, you don't have to worry about setting it manually.

✓ To intentionally blur an image with a moving subject (*motion blur*), set the shutter speed to a slower speed. To freeze the action in a shot, use a faster speed.

✓ When using a longer lens, you may need to increase the shutter speed to keep photos sharp. As a guideline, use a speed that's larger than the lens focal length. For example, if you're using a 55mm lens, anything over ⅟₆₀ is acceptable.

Figure 3-5 shows the blurring or motion effect possible with a slower shutter speed.

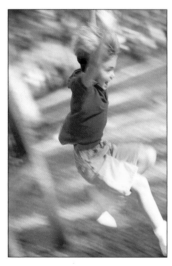

Photo credit: PhotoDisc

Figure 3-5: Set the shutter speed to a slower setting to blur an image.

Figure 3-6 shows action stopped by a higher shutter speed.

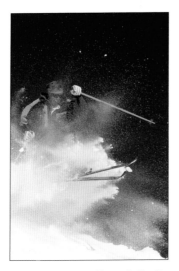

Photo credit: PhotoDisc

Figure 3-6: Set the shutter speed to a faster setting to freeze movement.

Changing the aperture

Like the iris in your eye, a camera lens can open wide or be narrowed to the size of a pin prick. The lens opening is the aperture. A wide aperture lets in more light. A narrow aperture lets in less light. As you walk through a dark room, your iris's aperture widens to let you see the dog that you're about to trip over. Flip on the light and your iris's aperture narrows quickly to reduce the flood of light.

A bright scene might call for a narrower aperture, whereas a dimmer scene may need a wider aperture. When you use a scene mode such as Cloudy or Night Sky, your camera chooses a wider aperture to let in more light because those are likely to be dimmer scenes. When you choose a beach or landscape scene mode, the camera automatically chooses a narrower aperture to reduce the light because those are likely to be bright scenes.

Another consideration is that aperture affects depth of field (DOF), the range in which objects are in focus. (Objects outside

the DOF — both closer and farther than the subject of the photo — are out of focus.) The narrower the aperture, the deeper the DOF. The wider the aperture, the shallower the DOF.

Words like *narrower* or *shallower* seem vague until you fully appreciate the dimension or direction being discussed. Aperture is like a window. A narrow window lets in less light than a wide window. DOF is like a clear patch on a foggy road. The more of the road ahead you can see beyond your headlights, the deeper the DOF.

Not surprisingly, DOF conveys depth. Photography converts three dimensions into two. A deep DOF can emphasize distance. Figure 3-7 ranges from a nearby ruin (in Hovenweep National Monument, Utah), across a valley toward a distant mountain range. This is the deep DOF that comes from a small aperture.

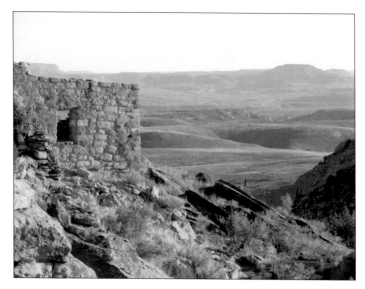

Photo credit: Mark Justice Hinton

Figure 3-7: Small aperture; deep DOF — miles deep.

You may want a shallow DOF to emphasize your subject by blurring objects in the background or foreground that distract. Figure 3-8 shows the shallow DOF that comes from a large aperture. The white apache plume flowers are in focus, but objects nearer and farther away are not.

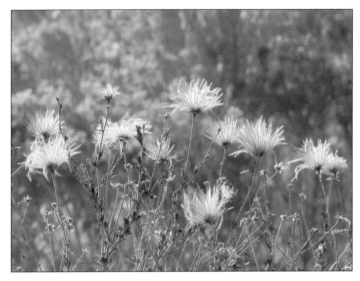

Photo credit: Mark Justice Hinton

Figure 3-8: Large aperture, shallow DOF.

This is the tricky aspect of DOF. Focus is not just on a single point or plane in space. There is a range nearer and farther than the subject that is also in focus. If your DOF is 6 feet and your subject is 3 feet away, everything between you and the subject and 3 feet beyond is in focus. With the same depth of field and a subject that is 30 feet away, the effect is quite different. Consider Figure 3-7 again. Imagine if the valley were in focus but the ruins were not — that would be the case with a shallow DOF. Keep that same shallow DOF and focus on the ruins and nothing in the valley will be distinct.

On a cloudy day or in a room lit only by daylight coming through windows, you might need to widen the aperture to get enough exposure. However, that wider aperture reduces the DOF, increasing the odds that some part of the scene falls outside the focus and is blurry or fuzzy. That's not necessarily bad — you can use that effect intentionally.

Aperture is measured in *f stops.* For example, f2.8 is a wide-open lens, admitting lots of light (with less DOF), whereas f8.0 is a narrow opening, admitting less light than f2.8 (but with greater DOF than f2.8). Every f stop has a specific DOF associated with it.

Notice the paradox of f stops: the higher the number, the narrower the aperture. That's because an f stop is a ratio (hang in there) of the width of the lens opening to the focal length of the lens. Traditionally, f2.8 is written as *f/2.8*; the lowercase *f* is the focal length and the aperture is the result of dividing the focal length of the lens by 2.8. As the f stop number (the divisor, really) gets higher, the aperture gets narrower. An aperture of f4 (or f/4) divides the focal length by four. One fourth is smaller than 1/2.8; f4 is narrower than f2.8; f8 is narrower still (1/8). With each step from f2.8 to f4 to f5.6 to f8, the aperture is narrower, admitting less light (and the DOF grows deeper with each step).

Interestingly, each f stop admits twice as much light as the next *higher* f stop and half as much light as the next *lower* f stop. (Relax, there won't be a quiz.)

If your camera has an Aperture Priority mode (usually an A or AP on the mode dial), use it to set the aperture you want and your camera automatically adjusts the shutter speed.

Shutter speed affects the freezing or blurring of moving objects within a scene.

All these details make you appreciate Automatic mode, don't they? But keep in mind that Automatic mode can't push the settings to change the mood or emphasize one part of the scene.

Your LCD or EVF will show you whether the scene is brighter or darker as you adjust aperture. You won't see the effect on DOF, however. DSLRs may have a preview button that shows DOF.

Keep these things in mind as you work with the aperture settings on your camera:

- Set the aperture by turning the dial (located on the front or top) and looking at the LCD display. On the Mode menu or dial, choose Aperture Priority mode, which may be labeled as A or Av (with the latter standing for *aperture value*). Setting your camera to Aperture Priority mode enables you to manually set the aperture while the camera determines all other settings. If you can't locate the dial, check your camera's user manual to see if your camera offers this mode.

✔ Look for an indicator in your EVF or on the LCD that the camera settings are within an approved programmed range. The indicator might be a green light (which means the settings are within range) or a red light (which means the settings are out of the approved range).

✔ The brighter the scene, the narrower the aperture you can use, meaning a higher-numbered f stop — as high as f8.0. For wider apertures (lower-numbered f stops), you should use a tripod to avoid camera shake and to ensure a sharp image. If you don't have a tripod and your camera has an image-stabilization feature, be sure to turn it on for wider apertures/lower f stops.

✔ Keep in mind that when you use Aperture Priority the shutter speed adjusts automatically.

Setting ISO

Before digital cameras, film was described as *fast* — very sensitive to light and fast to expose — or *slow* — less sensitive to light and slow to expose.

The standards for grading film's light sensitivity or *film speed* were established by the International Organization of Standards (ISO, an abbreviation taken from the French name of the organization). Although ISO is not a unit of measure, light sensitivity is graded in terms of ISO. Here, a bigger number indicates greater light sensitivity and faster exposure (and overexposure); a smaller number indicates less light sensitivity and slower exposure (or underexposure).

Although your digital camera doesn't use film, your camera's image sensor clearly is sensitive to light. And that sensitivity can be expressed as ISO.

Your camera has either a fixed ISO or chooses the ISO automatically based on conditions. You may be able to manually adjust the ISO. As you raise the ISO, you increase sensitivity — good for lower light. As you lower the ISO, you decrease sensitivity — good for normal or brighter light. Cameras often operate automatically around ISO 100 in most levels of daylight. ISO 1000 is very sensitive to light and might be appropriate for night shots with a tripod.

Vestiges of prior technology often carry forward into newer technology. What does clockwise mean anymore? Why do we still say that we dial our pushbutton phones? Likewise, ISO has been brought forward into the current age. Which is not to say that ISO is archaic. ISO provides a transition from old to new.

The dark side of using high ISO film is the resulting texture of a photo. Exposures at higher ISO tend to be grainy, speckled, or uneven because the increased sensitivity of high ISO film comes from larger grains of silver halide. The smaller, finer grains of lower ISO film produce smoother images.

Although digital cameras aren't subject to the chemistry of film, high ISO still has problems. The increased sensitivity of a high ISO digital setting increases interference and degrades the sharpness of photos. This interference is called *noise.* Noise is especially noticeable as defects in enlargements. Higher ISO may be noisier than low ISO settings, much as higher ISO film is grainier than low ISO film. To reduce degradation of the image, the highest ISO settings will surely require a tripod.

The practical significance of ISO is not merely that you may be able to shoot in low light. Higher ISO increases light sensitivity and that makes available narrower apertures (greater DOF) or faster shutter speeds than would be possible with lower ISO at low light. Settings that would underexpose a given ISO setting will adequately expose a higher ISO. An added benefit is that you may be able to shoot in low light without a tripod.

Understandably, you want your photos to have good exposure — not too bright, not too dark. ISO, aperture, and shutter speed are interrelated in regard to exposure. You can achieve the same level of exposure with different combinations of these settings. One of those combinations might result in more or less DOF. Another might freeze or blur motion. The exposure might be the same in each of these instances, but your options are different.

In the various preset modes, such as Automatic or Night Sky, your camera selects an ISO setting according to the lighting in the shot, as well as the aperture and shutter speed.

Go ahead, play with your ISO. Here are some things to think about as you play around with this setting:

✔ Look around until you find the ISO option on your camera. Because it's a less frequently adjusted setting, ISO may not be located with the other, more common options. (Many compact cameras don't let you change the ISO setting.)

✔ Press the ISO button and take a look at the ISO menu on your camera's LCD. Try setting the ISO speed. ISO speeds usually run at 50, 100, 200, 400, 800, 1600, or 3200.

✔ The lower the number of the ISO, the less sensitive your image sensor is to light. A low ISO number results in a photo with very fine grain. An ISO setting of 100 is considered average, but a low ISO speed may not work in low-light scenarios. Normally, you want the lowest ISO setting possible for best quality, unless you want a grainy shot for creative reasons.

✔ A high ISO number makes your image sensor more sensitive to light and creates a grainy, "noisy" image. High ISO settings may be necessary in low-light situations, especially when you're using a faster shutter speed, a narrower aperture, or both — for example, when you're shooting a moving subject inside a building.

✔ As with the other settings, you should take several similar shots, varying just the ISO setting. You may not be able to see any difference on your LCD. You're more likely to see differences on a computer screen.

Shooting in Manual mode

You can find ultimate control of your camera when you use Manual mode. This mode enables you to set each of the options discussed so far (shutter speed, aperture, and ISO). If you can juggle, you can use Manual mode.

When you use the semi-manual options, such as Shutter Priority, you select your desired shutter speed and the camera sets everything else based on that speed to produce a shot that is neither under- nor overexposed.

With Manual mode, you can override the adjustments the camera would make based on your semi-manual choices. For example, with Shutter Priority, as you increase shutter speed, you reduce the time for light to expose the image. Therefore,

the camera increases aperture to let more light in — reducing the DOF or increasing the noise, in the process. (The camera could change ISO, instead of aperture, to suit conditions and your shutter speed.)

In Manual mode, however, you can increase shutter speed and reduce aperture at the same time, something the camera would not do as you adjust only one setting. Faster shutter speed with narrower aperture will underexpose most images and may create a dramatic effect. That would also produce greater DOF than if you set a fast shutter speed and the camera automatically opened the aperture. If you manually increase the ISO at the same time, you change options even further.

Continue to play with the various manual settings. Trial and error will teach you something about the synergy of these settings.

With the semi-manual modes, such as Aperture Priority, you select the mode on the dial. To change the aperture, you use a different control, perhaps a wheel, lever, or dial. You'd use the same control with Shutter Priority mode. However, in Manual Mode, you can change multiple settings, so your camera provides a way to identify which setting you're changing at a given moment. Look for prompts on the LCD or EVF. The setting you are adjusting will be highlighted in some way. When in doubt, read the manual.

Figure 3-9 displays Manual mode — indicated by M in the upper-left corner — and other settings. The shutter speed is 125 and the aperture is f13.

Some of the buttons on your camera change function depending on mode or other settings. A common configuration on many cameras places four semicircular buttons around a button. Each of the smaller buttons has a dedicated function, such as Macro or Flash. In Manual mode, those buttons might move the selection highlight from one setting to the next. In Review mode, the same buttons might move you left and right through your photos.

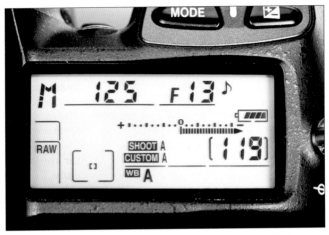

Figure 3-9: Set your camera to Manual mode to take control of your settings.

The following steps walk you through turning on Manual mode and taking a photo using those settings:

1. **Set the Mode dial or button to M (Manual mode) on your camera.**

2. **In Manual mode, make all decisions about setting aperture, shutter speed, and ISO. As you watch the LCD or EVF, select aperture and change it. You should see the scene turn darker or lighter. Select shutter speed and change it, watching the exposure change.**

 This preview is not 100% accurate in predicting what you'll actually get, but you will at least see some effect of changes to settings.

 The first few times you use Manual mode, be sure to try it in a casual situation that isn't a once-in-a-lifetime event such as a birth or a wedding. Consider taking some duplicate shots in Automatic mode.

3. **Compose your shot in the viewfinder or LCD screen.**

4. **Press the shutter button halfway to give your camera a moment to establish the shot.**

5. **Press the shutter button the rest of the way to capture the image.**

If your camera has a Program mode (P), you can set shutter speed and aperture at the same time rather than controlling one while the camera controls the other. Program mode stands between Automatic mode (the camera decides everything) and Manual mode (you decide everything).

Using a Tripod

Back in the days when Abraham Lincoln posed for the great photojournalist Mathew B. Brady, the subject of a photograph had to hold still while the photographer worked magic under a black cloth, muttering incantations and mixing potions. ("Eye of silver, tail of halide. . .")

A century and a half later, cameras are nearly small enough to strap to the back of a fly. Many of our subjects are in motion, and so are we (the photographers). Some conditions, however, still require holding the camera more still than most people are capable of holding it without assistance.

Many of the settings discussed in the preceding section of this chapter increase the odds of blurring, especially in low light. Furthermore, under less-than-ideal conditions, the slightest motion of the camera can introduce blur. (Try holding your camera rock-steady as you lean over a wall to photograph the running of the bulls. Picture abstract blurs with horns.)

The slightest camera movement is even more significant when you use a zoom lens that's fully extended or you use any lens in low light.

To diminish the possibility of undesirable blurring, many cameras provide some means of image stabilization. The lens may be isolated from movement by gyroscopes or special materials. The image sensor may be programmed — it's a computer chip, after all — to detect vibration and subtract that vibration from the final image.

Cameras with an image stabilization feature use it automatically. You may be able to turn it off, but you probably don't want to do that, except to experiment.

Despite the wonders of image stabilization, you may want to buy a tripod, the venerable tool of photography that even Mathew B. Brady would recognize after all these years.

Brady might be surprised by the variations in tripods, however. There are large tripods ranging from two to six feet tall with legs that fold or telescope. You may be able to set such a tripod at different heights using a twist or catch locking mechanism. Some tripods have pivoting connections so that you can incline the camera up, down, or sideways. You may even be able to remove the tripod head to hang it under the tripod (like a pot of beans over a campfire) for macro shots.

When is a tripod not a tripod? When it's a *monopod*. As you would expect, a monopod has a single leg — it's a walking stick with a camera connection. (Look for a monopod at a sporting goods or outdoor store if you often take your camera hiking.) Don't try to balance a monopod like a unicycle. Brace the monopod with your body or another stable object. The monopod's advantage over a tripod is that it is easier and faster to use and to move. Monopods are recommended over tripods when running with bulls.

Everyone needs a small tripod, something pocket-sized, for sheer convenience. And another small tripod style you might want to consider consists of a beanbag with a tripod connection for a malleable but stable bundle. (A beanbag drapes over a rock nicely.) Have I convinced you yet that you need a tripod?

Tripods are also useful for self-portraits and for group shots that you want to join. Use the self-timer and try not to trip over the tripod as you run to get in the shot. I don't mean that only as a joke — some cameras actually come with both short and long self-timer settings for your safety. So be sure to choose the setting that gives you enough time to get safely into the shot. Tripods are especially handy for taking movies, where any movement can be very distracting.

If you need a tripod but don't have one handy, you can try placing the camera on something steady, such as a wall. Or, brace yourself against a solid object such as a tree or a large rock. Opinions differ about holding your breath as you click.

(Seriously.) You could also increase the ISO to allow for a faster shutter speed or smaller aperture.

When you have a real tripod available and are ready to put it to use, follow these steps to use it successfully:

1. **Attach your camera to the tripod by screwing the tripod screw into the mount under the camera body.**

 Some tripods come equipped with a quick-connect plate that detaches from the tripod. If your tripod is so equipped, attach the plate to your camera ahead of time and use it to quickly attach and detach from the tripod.

2. **Establish the height of your tripod by adjusting the legs and neck of the tripod. Be sure to lock the legs and neck so that they don't slip. Get the height right to avoid straining your own neck as you compose the shot.**

3. **Adjust the head of the tripod until you have the exact angle you want for the camera.**

4. **Use the LCD screen and check the height and angle. Make any necessary adjustments.**

5. **If you're using a lens with an Image Stabilization or Vibration Reduction setting, you may want to turn that setting off when using a tripod (unless the lens also has a setting for detecting tripods).**

 Image Stabilization and Vibration Reduction settings enable you to hold a camera and decrease the incidence of camera shake. When you use a tripod, however, these settings can cause your photos to be blurry if the image stabilization feature actually tries to compensate for movement or shake that doesn't exist. (Ironic, isn't it?) Check your owner's manual for suggestions on using tripods with image stabilization.

Tripods are especially vital for taking shots that require the shutter speed to be slower, thereby helping to eliminate camera shake. Slower shutter speeds, which enable you to use wider aperture settings, are often used in low-light situations, such as bad weather, sunsets, and nighttime. You will also want to use one when using a telephoto or an ultrazoom lens.

4

Composing Better Shots

· ·

· ·

*O*ne of the great things about digital photography is that it doesn't require a lot of thought. You can simply point your camera and click the shutter. (Okay, you do have to remember to turn it one and remove the lens cap, if the camera doesn't do that *automagically*.)

A camera is like a computer. Wait, that's a good thing! A camera has capabilities that you can ignore as long as you like. When you start looking deeper, you find more and more that you can do with your camera.

Even if you're using the simplest point-and-shoot camera without any extra options, you still control the shot. You select the subject and frame it within your view finder.

In this chapter, you look through the lens to see something new. You also explore various ideas for composing a photo to maximize your subject and minimize distractions.

Seeing through the Lens

Focus is vital in photography. A picture in focus is sharp and clear. A picture with the subject out-of-focus is probably a dud.

One problem with focusing a camera is that you're focusing your eye on something right in front of your face (the EVF or LCD), whereas your camera is focusing on the subject (you hope). Putting a lens (and everything else) between your eye and the subject requires seeing things in a slightly different way. It may help to understand how cameras focus and what you can do to control that.

Nailing your focus

When you raise your eyes from this page to look across the room, you continuously focus on whatever you're looking at. You don't think about fixing focus, unless you just woke up.

Most cameras don't work the way your eyes do, unless you change an option in setup. You can think of camera focus as consisting of three parts: when to focus, where in the frame to focus, and the distance between you and the subject. Each of these three elements can be handled by the camera or by you through your camera's setup menu or other controls.

When to focus

Normally, your camera only focuses when you press the shutter button halfway. That's why you do that, to give the camera a moment to focus (as well as to set exposure). That standard method of automatic focus (Auto Focus, or AF) is fine for subjects that aren't moving much. You simply need to get used to the fraction of a second delay as the camera focuses. (DSLRs don't usually have this focus delay. Refer to Chapter 1 for more about the different types of cameras.) Your camera may call this One Shot AF or Single Shot AF.

For subjects that are moving, you may need another form of automatic focus: Continuous Auto Focus (CAF). As the name implies, CAF constantly focuses, even when you are not pressing the shutter button. An advantage of CAF is the elimination of that brief delay for focusing, which is great for catching subjects in motion. A disadvantage of CAF is the drain on the

batteries caused by the constant focusing. CAF may also have some associated noise as it constantly adjusts focus, and this may result in a modest increase in wear and tear on the mechanism.

Where in the frame to focus

But what is the camera actually focusing on? Does a camera recognize the subject of a photo? You may want to focus on that pretty bird in the tree, while the camera is automatically focusing on the twig in the foreground, blurring the bird. What determines the *focal point* (the part of the frame used to focus)? Focal point sounds too small — think of this instead as the *focus area* that the camera uses to focus.

Your camera doesn't know what the subject of the photo is. Instead, your camera is set to focus on one or more areas within the frame. Standard AF uses a relatively wide area around the center of the frame to focus. You may see this as a rectangle or brackets on your EVF or LCD. (The rectangle or brackets may turn green when the subject is in focus.)

Your camera may let you choose Center Focus (CF). With CF, the focus area is reduced to more of a square than a broad rectangle. Use CF to reduce the area the camera focuses on, such as when you want to photograph one person in a crowd.

Some cameras feature Multipoint Focus (MF), in which the camera focuses on a number of areas (determined by the manufacturer, in most cases). Some recent cameras have a variation on MF called *face detection*, as well as *smile detection*. These cameras are programmed to recognize faces and smiles. (Really!)

The distance between you and the subject

Regardless of when or where the camera is focusing, how does it know that your subject is six feet and not twenty feet away? This is another task that the brain handles subconsciously, in most cases, but cameras are programmed to calculate.

Most cameras measure distance by using some form of range-finder based on optics, infrared (especially in low light), or sound (like a bat). Lasers were used until the first few subjects vanished in a puff of smoke. (Just kidding!)

The camera's calculation of how far away the subject is can be affected by low light or objects between the lens and the subject. So, that's where Manual Focus comes in. When you choose Manual Focus, you tell your camera how far away the subject is by using left (closer) and right (farther) controls while watching a scale on-screen with distances marked up to infinity. Manual Focus takes the control away from the camera and leaves it to you to guess distances accurately. Manual Focus is not very useful for moving subjects.

Locking focus

In most cases, pressing the shutter button halfway locks the focus until you press all the way down or release the button, no matter how focus was determined by the camera. You might deliberately lock focus on a subject before moving the camera a little to one side or the other. This takes the subject out of the center of the frame but ensures that the subject is in focus. An off-center subject may be more interesting, as long as the subject is in focus.

When you want to shoot a subject off-center, lock the focus. Set the Auto Focus option to Center Focus or One Shot AF mode. If your camera has an option to select a single focus point or AF, select it. (Check your camera's user manual to find out how.)

Figure 4-1 shows an off-center subject. For this photo, the shutter button was pressed halfway down to lock the focus with the subject in the center of the frame. Then the camera was moved to create a more interesting composition.

Locking focus on a subject can help you in situations where the camera might focus on the wrong thing. For example, when you're photographing a bird in a tree, the camera might focus on branches closer to you than the bird. To adjust for this, focus on an object the same distance from you as the bird, lock the focus, and move the camera to frame the bird. (This trick works on other subjects, too. It requires a good sense of distance.) Similarly, focusing on the space between two people might put both out of focus. Focus on one, lock the focus, and move the camera to put them both in the frame.

Figure 4-1: Lock the focus before you shoot an off-center subject.

Working with depth of field

No matter which mechanism your camera uses to focus — Auto Focus, Manual Focus, Center Focus, Multipoint Focus — there is always the issue of depth of field (DOF). DOF is covered in Chapter 3. You may recall that there is a range in front of the focal point (the area between the camera and the subject) and beyond or behind the subject that is in focus — that's the DOF.

Imagine three rows of volleyball players standing on bleachers. If the camera focuses on the middle row, will the players in the first and last row be in focus? They will be if there is sufficient DOF. If the DOF is shallow, the other rows will be out of focus.

That may be just what you want if you like someone in the middle row.

Aperture directly affects DOF. If you are operating in any mode other than Aperture Priority, Program mode, or Manual mode, the aperture setting remains in the camera's control, along with the DOF. (See Chapter 3 if you need a refresher on how aperture affects DOF or to find out more about Program mode.) There is nothing wrong with letting the camera manage settings. When you control the aperture and DOF settings, you may create photos that are different from what the camera would do automatically. Those photos may be better, but some surely will be worse as you experiment. You have to break a lot of eggs to photograph an omelet.

 To play around with DOF, look in the early morning and late afternoon for natural spotlighting of bright objects in front of darker, shaded backgrounds.

Figure 4-2 shows an image of a coneflower with a very shallow depth of field, resulting in a blurred background.

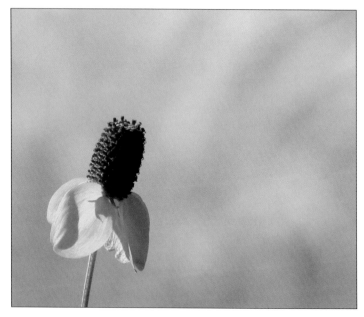

Photo credit: Mark Justice Hinton

Figure 4-2: An image with a shallow depth of field.

Figure 4-3, on the other hand, shows Lily Pond in Colorado, with a very deep depth of field that results in near and far objects that look equally sharp.

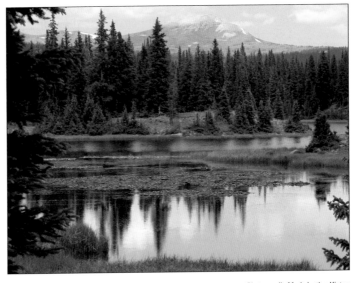

Photo credit: Mark Justice Hinton

Figure 4-3: An image with a deep depth of field.

If you want to create a shallow depth of field, use one of the techniques from the following list:

- ✓ **Shoot in Portrait mode.** Look for an icon of head and shoulders. This mode sets the camera to a larger aperture.

- ✓ **Set your camera to Aperture Priority (A or Av) mode.** Choose a wide aperture, which, ironically, is indicated by a lower f stop number. For example, f2.8 is a larger aperture than f16. Try various aperture settings to create the DOF you're looking for. (See Chapter 3 if you need a refresher on setting the aperture.)

- ✓ **Use a telephoto lens and fill your frame with the subject.** The longer the focal length of your lens, the shallower the DOF.

- ✓ **Move close to your subject.** The closer you are, the shallower the DOF.

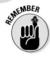

On most consumer and prosumer cameras, you won't really see the DOF until you look at the picture afterward. DSLRs may have a preview button that helps you see the DOF.

In you want to create a deep DOF, try one of these techniques:

✔ **Shoot in Landscape mode.** Look for the mountain icon on your camera. This mode sets the camera to a narrower aperture.

✔ **Set your camera to Aperture Priority (A or Av) mode.** Choose a narrow aperture, such as f16 or f22. Experiment with settings to create the depth of field you want.

✔ **Use a wide-angle lens to increase the impact of a deep DOF.**

✔ **Move farther away from your subject.**

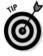

Keep in mind that DOF refers to how much area is *in focus* in front and in back of your subject. When you want to minimize a busy, distracting background and make your subject a strong focal point, use a shallow DOF, which blurs the background. When you want the entire image (from the foreground to the background) to be sharply in focus, use a deep DOF.

Metering to evaluate scene brightness

For each photo you shoot, your camera evaluates the available light and analyzes the areas of light and dark within the frame. This analysis is called *metering* and comes from the traditional film technique that involves a hand-held or internal light meter. With a hand-held light meter, you can aim the meter at the part of the scene you want to use to determine the exposure (this is called *metering off* an object). Even though most nonprofessional camera owners won't use a hand-held meter, your camera has a built-in device that meters off all or part of the scene.

To control the exposure, especially in scenes with stark contrast between light and dark areas, consider how the camera determines the brightness of a scene. Imagine a marble statue surrounded by dark-green vegetation. If you meter off the statue, say, by moving close to it or zooming in, the camera

adjusts for a bright scene and avoids overexposure. In the process, the greenery may be underexposed, which is not necessarily bad. If you meter off the greenery, either by aiming away from the statue or by backing off so that the statue is a small part of the scene, the camera adjusts for a darker scene and avoids underexposure. In the process, the statue will probably be overexposed.

All DSLRs and many prosumer cameras use various metering methods. These methods define the way the image sensor in the camera measures the light in the shot and calculates the appropriate exposure for the image.

Some of these metering methods are described in the following list:

- **Evaluative metering (also known as *matrix*, *multi-segment*, or *multi-zone* metering):** This method looks at the subject's position and brightness and the foreground, middle ground, and background lighting. Evaluative metering evaluates up to 100% of the scene and averages the lighting to determine the appropriate exposure.

 For most scenes, this is a sensible metering method, which is why evaluative metering is the standard method used by most cameras unless you choose otherwise. As you would expect, some cameras enable metering changes, and some do not.

- **Spot, or partial, metering:** This method of metering bases exposure on the light in the center of the frame (approximately 10 to 15 percent of the frame). You might choose spot metering for backlit scenes, in which the background is much brighter than the subject. Doing so causes the camera to adjust to let in more light to properly expose the backlit subject. That, in turn, may overexpose the background. If you want a silhouette, you may want to meter off the bright background to cause the camera to underexpose the subject.

- **Center-weighted metering:** This method meters off the center, giving that information *weight* (emphasis or preference) and then meters the rest of the scene. This isn't quite an average because it is weighted toward the center metering, making this a cross between evaluative and spot metering. This mode is good for complex lighting situations.

If your camera offers metering options, take a few minutes to explore them by following these steps:

1. **Put your camera in Manual (M) mode and press the Metering button or choose the setup menu.**

 Generally, this mode is indicated by an eye icon; check your camera's user's manual if you don't see that icon.

2. **Select from the available metering modes on the menu: evaluative (or multi), spot, or center-weighted. (See the descriptions in the preceding bullet list if you need help in choosing a mode.)**

3. **Take a few different shots from the same spot, looking for a variety of light and contrast.**

4. **Without moving from that spot, switch metering methods and take the same shots.**

The various effects you get from different metering methods can be very subtle on your camera's LCD. To really tell the difference among images, you need to transfer the photos to your computer and compare them on that screen. (See Chapter 6 for help with reviewing your photos on your camera and on your computer.)

Composing the Photograph

So far, we've had you pretty fixated on technology — simply nailing down how to find and select the right setting for a particular shot. In this section, we help you snap up some technique (okay, bad pun). People have been taking and viewing photographs for ages, and you get to benefit from all they've learned.

The concept of *point-and-shoot* belies the amount of thought that precedes good *composition*, which is the conscious arrangement of elements in a scene. Along with juggling various mechanical settings — or using Automatic mode — consider improving the composition of your photograph by incorporating the suggestions discussed in this section. You find out how to place and enhance the subject, how to minimize distractions,

and some ways to develop a particular mood for a shot. You may also see some photos that defy guidelines but are interesting, nonetheless.

Finding a focal point

If a photo contains too many elements, the eye doesn't know where to look first. Beware the wandering eye. A focal point draws your viewer to a main point of interest within the image. One of the easiest compositional tasks is to find a clearly defined focal point.

Consider a city street corner with a lot of traffic signs, a couple of billboards, and dozens of people moving in every direction. That chaos might actually be the subject of a photo. But if the actual subject is a dog sitting by a lamppost, people looking at the photo may miss that point. (The *Where's Waldo?* series proves people enjoy hunting for the subject under some circumstances.)

A clear focal point should include only necessary elements that contribute to the compositional strength or emotional impact of your image, eliminating distractions. Here are a couple of suggestions:

- ✔ If you're photographing people or animals, try to get close to them by moving or using a zoom lens. (Using the zoom allows for more candid photos.)

- ✔ If you're shooting open scenes, find something interesting to include in the frame. Shots of mountains and beaches are fine, but how many are truly memorable? Throw in a climber scaling the mountain wall or a surfer wiping out on a wave and you elevate the visual impact to another level.

Elements that distract from your focal point, and which you should try to avoid, include too much background and random clutter and bystanders.

Figure 4-4 shows an off-center focal point (a sunflower seedling) emphasized by natural lighting.

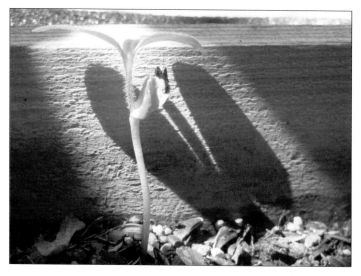

Photo credit: Mark Justice Hinton

Figure 4-4: The focal point can be anywhere in the frame.

Every guideline has exceptions. A field of flowers may not have a focal point but may smell as sweet.

Reducing background clutter

Most people worry only about cutting off people's heads when they shoot. (Now that's a gruesome sentence!) However, a bigger problem is that most people include too many elements in their shots, distracting from the focal point. Try to eliminate background clutter that adds nothing to the value of your shot.

Here are a few tips for reducing unnecessary elements in your photo compositions:

- **Get close.** Fill your frame with your subject.

- **Move your camera, yourself, or your subject.** Try shooting a vertical or diagonal shot if the subject warrants it. If moving your camera isn't enough, move around your subject and try unexpected angles. Look for compositions that minimize or avoid distracting elements around your subject, such as poles, wires, fences, or bright lights.

✓ **Include only complementary background elements.** If your background elements are interesting and give context to your subject, include them. These elements can include props, landmarks, and natural components.

✓ **Try blurring an unavoidable, undesirable background.** Sometimes you can do this by using a wider aperture on your camera, such as f4 instead of f11 or f16. This strategy makes the depth of field shallower so that your subject is sharp but the background isn't. Keep in mind that some consumer digital cameras use image sensors that are about one-third the size of a 35mm frame, making the lens close to the sensor, which increases the depth of field. This type of sensor can make it hard to blur the background. You can always blur the background by applying a blur filter during editing.

You can move around your subject, choosing the least distracting or most interesting background for your shot.

Following the Rule of Thirds

Very few photographic guidelines have been elevated to the status of a *rule*, but this section tells you about one of them. The Rule of Thirds divides the photo into horizontal thirds, vertical thirds, or a grid of nine squares (3 x 3).

For a very simple example of the effect of thirds, stand where you can see the horizon. Looking through the VF or using the LCD, position the horizon one third up from the bottom of the frame. Shoot or take a mental picture. Move the camera slightly to position the horizon two-thirds up from the bottom. Which of these pictures is better depends on your intent and the subject. Either may be better than dividing the frame in half with the horizon.

Figure 4-5 shows a photo of a kayaker overlaid with a grid. The Rule of Thirds suggests that the focal point should be at or near one of the four intersections around the middle of the picture, along one of the thirds — vertical, horizontal, or both. Placing the subject or focal point along the thirds makes it more likely to be noticed first and, some say, is subconsciously more pleasing.

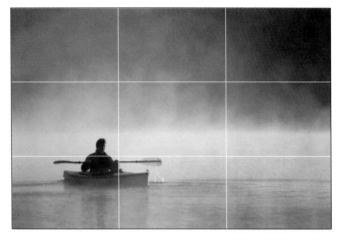

Photo credit: Corbis Digital Stock

Figure 4-5: Position your subject by using the Rule of Thirds.

Regarding Figure 4-5, you could argue that the center of the kayaker's body should be on the closest intersection point. The bottom horizontal gridline could run through the paddle, the kayak (lower) or the line in the water (lower still). Each adjustment would be a different photograph. All might be better than the kayaker in the center of the frame. Remember, the Rule of Thirds is only a guideline.

To apply the Rule of Thirds to various shots, consider these examples:

- **In a scenic shot:** A low horizon creates a spacious feeling; a high horizon gives an intimate feeling.

- **In a portrait:** Try putting the face or eyes of the person along a vertical or horizontal third or at one of the four points of intersection.

If you have a camera with Auto Focus, lock the focus when you're moving from center because the Auto Focus sensor locks on to whatever is in the center of the viewfinder (unless you've manually chosen a different focus method). Center your subject in the viewfinder and apply slight pressure to the shutter release button to lock the focus. Then reposition your subject at an intersecting point and press the shutter release the rest of the way to take the photo.

Even the mighty Rule of Thirds has exceptions. You may choose to put your subject dead center, knowing that you expect to crop the picture later, either filling the frame with the subject or cropping with the subject off-center (and, more than likely, along one of the thirds).

Photography is fun. Editing is work.

Avoiding mergers

As you intently frame and compose your photo, you might fail to see a branch in the background that will seem to grow out of your friend's ear in the final photo. Such a gaffe is called a *merger*. Or, you might not notice that you're chopping off someone's hand or foot. This is known as a *border merger*.

Effects like these are common and amusing and, with luck, not too embarrassing. You can avoid mergers by thoroughly scanning the preview in the EVF or LCD and thinking about the background and foreground as much as you do about the subject. You may be able to avoid a problem with the background by moving your position or by reducing the depth of field (widening the aperture with a lower f stop).

Figure 4-6 shows a border merger attacking a cheetah.

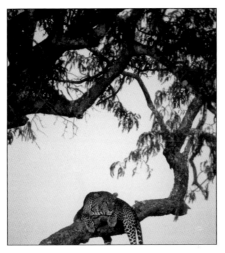

Photo credit: Corbis Digital Stock

Figure 4-6: Avoid border mergers.

With the best photo editing software and enough time, it's easier to brush away a branch than to restore a severed limb.

Looking for balance

You create balance in an image through the arrangement or placement of the elements in the image. Balance can be *symmetrical* (harmonious or formal) or *asymmetrical* (dynamic or informal). Think of balance in regard to color, shape, and contrast.

Imagine two photographs of a chessboard. In the first, all the pieces are lined up before the game begins. Shot from above or from the level of the board, the scene has a natural symmetry and balance among the pieces.

Now, the game is over. In a corner, two pieces stand over the fallen king — checkmate! The unbalanced image is part of the story.

Figure 4-7 shows a balanced rock, or *hoodoo,* as an example of asymmetrical balance — that rock will fall in a century or so. In this case, the subject itself is dynamic (if only in geologic time) and tense. Notice, as well, the rough thirds described by the foreground, the mountains, and the sky. The balancing rock is also along one vertical third, tipping over one of the four intersections. The stark contrast on the two sides of the spire is another element of balance.

Finding leading lines

With some photos, your eye wanders haphazardly across the image, which isn't necessarily a bad thing. However, you may want to compose a stronger picture that leads the eye purposefully across the image.

Leading lines draw the eye into the picture. They add dimension and depth and can be actual lines or lines implied by the composition of elements.

To compose photos with leading lines, look for elements such as roads, fences, rivers, and bridges. Diagonal lines are dynamic. Curved lines are harmonious. Horizontal lines are peaceful. Vertical lines are active — or so some people say. Regardless of emotive quality, a line leads the eye.

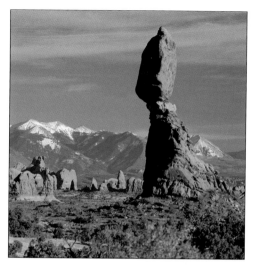

Photo credit: PhotoDisc

Figure 4-7: Asymmetrical balance creates tension
and implies impending motion.

The line of clouds in this photo of Chaco Canyon, New Mexico, shown in Figure 4-8, demonstrates how a leading line can direct your eye across an image. In Figure 4-8, the horizon (along the lower third) doesn't draw the eye left or right. The clouds lead the eye toward the lower right — and there's Waldo! This print may be too small for you to see the photographer's shadow in the lower-right corner. Such a shadow is generally regarded as a mistake. Here, it was intentional.

Keeping the horizon straight

For some reason, people expect horizons to be horizontal. (That must have something to do with the real world.) You can spoil a dramatic sunrise or sunset by too much tilt to the left or right. Try to keep a straight head on your shoulders or learn to compensate for your natural inclinations.

Figure 4-9 shows a flat, straight horizon. What rule does this figure violate? *Hint:* It's the only rule in this chapter. The Rule of Thirds suggests moving the horizon up as much again as you see here, showing more of the foreground. Would that be a better shot? Following rules doesn't guarantee anything.

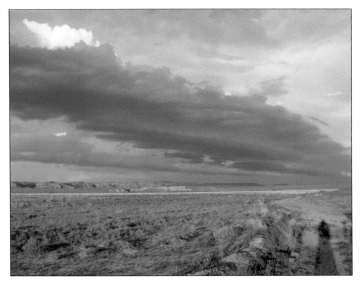

Photo credit: Mark Justice Hinton

Figure 4-8: Leading lines (the clouds, in this case) bring the eye into and across the image.

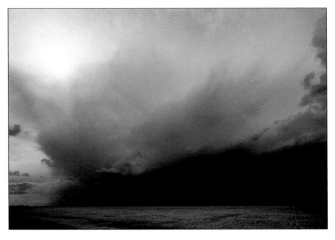

Photo credit: Corbis Digital Stock

Figure 4-9: Keep horizons straight.

If your camera has a viewfinder screen with a built-in grid for the purpose of helping you keep the horizon straight, use it.

Alternatively, you can purchase a bubble-level accessory to let you know whether your camera is tilted.

Using a tripod can also help keep your horizons straight. And some tripods come with built-in bubble levels. Just make sure that the legs of your tripod are extended properly — equally on level ground, or lopsidedly on uneven ground — to make the camera level. (You can read more about using a tripod in Chapter 3.)

Keep in mind that once you know the rules, you can always break them. But it's much more fun to break the rules you know than to operate out of ignorance.

Framing the subject

The term *frame* is used to describe the image itself. You frame your subject, and the lines in the composition, such as the horizon or roads — as well as movement — extend beyond the frame. Inside this frame, you can further frame the subject by including elements around the foreground that surround the subject. Imagine a lake appearing flanked by trees or a shot through a doorway or window looking inside or looking outside.

Figure 4-10 shows a doorway in Chaco Canyon framing part of a room beyond within the frame of the photo. The doorway in this photo may violate the Rule of Thirds because the right edge cuts the scene in half, unless you imagine the left-hand vertical third down the middle of the doorway. Showing more of the wall to the right would be more in line with the Rule of Thirds (one-third doorway, two-thirds wall).

Here are a few more points to keep in mind about framing within a photo:

- ✓ **A frame welcomes you to an image, adds depth, and creates a point of reference.**

- ✓ **To compose photos with frames, use foreground elements to frame your subjects.** Elements such as tree branches, windows, and doorways can frame wide or long shots. Close-up shots can also be framed.

- ✓ **Decide whether to keep your framing elements sharply focused or soft.** Depending on the shot, sometimes sharply focused framing elements can distract from, rather than enhance, the focal point.

Photo credit: Mark Justice Hinton

Figure 4-10: It can be fun to put frames within frames.

Creating a mood with distance

A memorable photograph often creates or conveys a mood. The subject is clearly significant, but light and distance also impart a mood.

Getting close to your subject may make the image personal, warm, and inviting. Avoid including excessive background elements, and intimately fill your frame with your subject, especially when photographing people.

Figure 4-11 shows the subject's joy in an odd find on the trail (a gastrolith). This photo illustrates the intimacy that comes with getting close to your subject.

You might even violate guidelines for framing and against mergers by getting exaggeratedly close to your subject. A

close-up of a face, even just eyes, nose, and mouth, can be very interesting. A good zoom lens allows you to get especially close without aggravating your subject.

And just as shooting close can create a feeling of intimacy, shooting a subject with a lot of space around it can evoke a sense of loneliness or isolation. It all depends on your intended message.

Photo credit: Mark Justice Hinton

Figure 4-11: Getting close to your subject affects the mood of the picture.

Use eye contact when photographing people. Remember that children, animals, and other height-challenged subjects aren't at the same eye level as adults. Try getting down on the ground, to their level, if necessary.

Using texture and shape

When composing your shot, look for interesting textures to add definition and for lines and shapes to create interest. Remember that textures and shapes are enhanced by the use of light and shadow. These elements come into play even more when you're shooting black-and-white images.

Figure 4-12 shows the effect of texture in an image. This photo of a rock wall in Chetro Ketl, New Mexico, emphasizes the natural texture of the stone plus the sculptural quality of the mason's work. This photo might be even more interesting in black and white.

Check your camera's settings or refer to your user's guide to see whether your camera offers a black-and-white (B&W) setting. Alternatively, you can switch from color to B&W during editing.

Photo credit: Mark Justice Hinton

Figure 4-12: Using texture for added definition.

5

Photographing Special Subjects

*E*very photographer has a favorite or special subject. You may like zoos, or you may be the one your friends expect to photograph their wedding. The land, sky, or water may be your thing.

Beyond the general guidelines and principles of photography (see Chapters 3 and 4), you'll find that special subjects warrant special handling. A wedding is not a zoo, no matter how it feels on that special day. Birthday parties and rainy landscapes require different plans — such as how to wipe icing versus mud off the camera.

In this chapter, you consider people, animals, events, and places as subjects presenting unique challenges and opportunities. Of course, these topics can overlap — you can get married at the zoo in a rainstorm. Now those would be some pictures!

The advantage of digital photography is that you don't have to worry about the cost and time spent in film processing, so you can let your experimental and creative juices flow and take lots of pictures without worry or guilt. Just be sure to spend enough time with your camera before the big day to avoid unpleasant surprises. ("What lens cap?")

Capturing People and Animals

Most people love looking at people and other animals. There are countless ways to photograph the creatures we encounter at home, around town, and in the wild.

Everybody loves a picture of a grinning human baby, a cuddly kitty, or a playful puppy — well, maybe not everybody, but you may not want to know anyone who hates all three. And don't leave out birds and bugs — or plants, for that matter — all can capture the heart and imagination.

The best photographs tell a story or convey a mood. A photo can cause us to share even a stranger's joy or sorrow, draw a breath at the sight of some lovely creature, or recall or imagine what it was like the day that photo was taken.

Photographs freeze a moment or an aspect of life. You may cringe at the sight years later; but more likely, everyone will delight in seeing how things used to be.

Taking a portrait

A portrait of one or two people can be very formal or casual. The subject of a portrait can fill the image or be framed by the immediate surroundings. And you can shoot a portrait in either portrait or landscape orientation.

The best portraits do more than merely capture an instant in a person's life — they reveal something unique or memorable about that person in that captured moment.

Don't worry about creating *art* — a candid snapshot can become a treasured keepsake. But if time and circumstance allow, invest some thought in the composition. Figure 5-1 shows a candid portrait of a subject absorbed by what he is seeing.

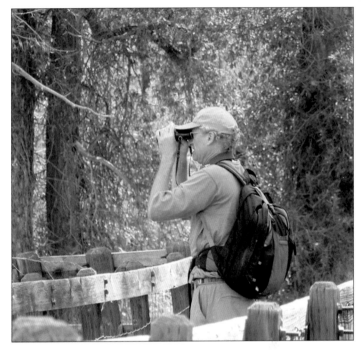

Photo credit: Mark Justice Hinton

Figure 5-1: A candid portrait can become a treasured keepsake.

When you're shooting a portrait, the most important thing you can do is take care of your subject. Here are some suggestions on how to do just that:

- ✓ If possible, photograph the person in a location where she feels comfortable. Chat with her and make her feel relaxed.

- ✓ To achieve the highest level of intimacy and engagement by viewers of the portrait, go for direct eye contact — that is, have your subject looking straight toward your lens. If your subject is looking away from the camera, however (which can add mystery), decide whether you want to include any of the surroundings to show the person's point of view.

- ✓ Sunglasses and hats shading the eyes can make or spoil the shot. So think about whether you want your subject to remove them.

✓ Try to include some context in a portrait, which means photographing the person in surroundings that speak to who she is: her profession, hobby, or personal life. Include tools of the trade or props, if appropriate.

✓ If the person is posing, try to grab some candid shots when she isn't paying attention. If you're posing her, have her turn slightly to the side, angle her shoulders, and lean in slightly toward the camera. Watch out for glare on eyeglasses.

✓ For children, get down to their level, be patient, and take some candid shots. Let children lose their shyness in play.

With two people centered in the frame, you may have trouble focusing on them and not the background between them when you use Auto Focus. Try focusing on one person and locking the focus by pressing the shutter halfway down. Then reposition the camera on the couple and press the shutter the rest of the way.

After making your subject comfortable, compose your photograph and choose your settings. Here are some things to consider before you shoot:

✓ Incorporate general rules about composition (see Chapter 4), such as moving in close and using the Rule of Thirds (discussed in Chapter 4) for a great portrait. Place the eyes along an intersecting grid line and reduce background clutter unless it contributes to the shot in some way.

✓ Many cameras have a Portrait mode that keeps your subject in focus while blurring the background (look for an icon with a head). Some cameras also have a Portrait/ Landscape setting, which keeps both the subject and background in focus (the icon may be a head in front of a triangular mountain symbol).

✓ Shoot a variety of shots: close-ups, medium shots, and even full body. Create a lot of images that you can choose from.

✓ Outside, shoot in natural light at a 45-degree angle to the sun. Overcast days create a soft, flattering light. Shooting right before sunset creates a soft, warm light. Avoid harsh midday sun at all costs. People squint, and the sun causes nasty shadows across the face.

✔ Inside, place people near a window, at a 45-degree angle to the light. If you need to light the shadowed side of the face, place something reflective nearby, such as light-colored cardboard or even a lamp (with or without a shade), placed at a 45-degree angle. Remember that soft lighting is the key with portraits. If you must use a flash, be sure to set Red-Eye Reduction mode. (You can also correct red-eye in editing. See Chapter 7 for more about avoiding and fixing the problem of red-eye.)

✔ Keep a low ISO (100 to 200) to minimize noise. ISO settings refer to how sensitive the image sensor is to light. If you're using a slow shutter, use a tripod to ensure a sharp capture. If you're shooting in Manual mode and not using a tripod, set the shutter to around $\frac{1}{125}$ second.

If you're photographing someone you don't know — for example, someone you run into while on vacation — be sure to ask for the person's permission.

Getting the group

Photographing a group takes determination and cooperation. Teams are easy; families can be trickier. Don't even try to get everyone at the bus stop to pose together.

Take all the considerations of a portrait and multiply them by the number in a group. How many people will have their eyes closed? Will everyone look at the camera and smile at the same time? At the very least, be prepared to take extra pictures.

Sometimes, taking a great group shot is a matter of serendipity. But usually it requires direction and setup from the photographer. Don't be afraid to play director and tell people where and how to stand, sit, or position themselves. Just be considerate of people's time and don't make them wait too long.

Find the best location and, if possible, use props such as viewing stands, steps, picnic tables, trees, or other elements to arrange people.

After you scout and set up the location, position people in a variety of poses. Depending on the number of people, having some sit or kneel in front and others stand in back can work well. Stagger people in front and behind.

Having people get close, tilting their heads toward each other and even touching one another, often makes the shot more intimate and engaging. Figure 5-2 shows a group barely squeezed into a tent.

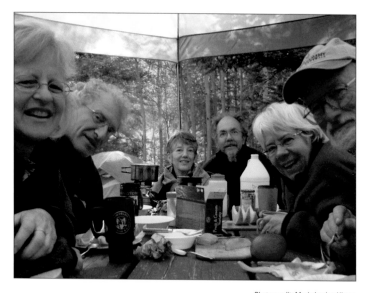

Photo credit: Mark Justice Hinton

Figure 5-2: Direct people how to fit within the frame.

You can join the group by setting up the shot on a tripod and using the self-timer. Let everyone know what position you'll take when you join the group and make sure you'll fit in the frame. Make everyone hold positions until you check the photo.

If you have an especially large group of people or active kids or pets, ask for a volunteer to help with the directing. And when photographing really large groups, if you move higher and focus down on the group, you can squeeze more people into the frame.

If a group of people is engaged in an activity, like a game, bring elements of the location or activity into the shot to give the photo context.

Finally, after you set up the shot, try to get people to relax. Use humor to get people to smile naturally. It's the next best thing to spontaneity.

Capturing animals in the shot

Wild or tame, animals touch us all in some way. Some photos of animals can be staged, as you can stage portraits of humans. Your dog may sit on command. Your cat may ignore you and refuse to move out of the frame. The hamster's got no place to go on that wheel.

Figure 5-3 shows a portrait of a contemplative pet cat.

Photo credit: Mark Justice Hinton

Figure 5-3: Animal portraits can be as engaging as those of humans.

Unless you are trying to take a photo of a pet rock or a Tamagochi, be ready for unexpected movement. Take multiple shots in close, and then move back and take some more. (Move in and out physically or with a zoom lens. Keep in mind that zooming in usually reduces the depth of field.)

Spontaneous animal photos involve more luck with the timing. The first step with any spontaneous photo is to always have your camera ready. That means the lens cap is off and the camera is on anytime you might luck into a photo. You may even want to keep your hand on the trigger. This is the price of your art: eternal vigilance.

Figure 5-4 shows a flock of snow geese taking off. Be ready for the unexpected movement of animals.

Photo credit: Mark Justice Hinton

Figure 5-4: Spontaneity happens, although some animal movements are predictable.

To conserve battery power, your camera shuts down after a preset idle period. Using the set-up menus, you may be able to make the idle period longer for readiness at the expense of power. You can also half-press the shutter periodically to keep the power on.

You can also improve your chances of getting a good, spontaneous shot by observing animal behavior. What part of the fence do the birds favor? In which direction is that animal likely to move? Will it pause for a second? (It might, if you don't alarm it. Animals are curious, too.) When you know which way the butterfly will turn, you've reached *nerdvana*.

If possible, move the camera down to the animal's level. For an intimate photo, capture the animal closely and at eye level. If you can't get close physically, use a zoom lens. Get your pet's attention by holding a treat or toy next to the camera.

Photograph the animal in a location it likes so that the animal is relaxed and feels comfortable. A location that provides context adds to the ambience of the photo. A source of water usually draws wildlife.

Try to capture the animal's personality and charm. Is your dog a live wire? Is your cat the ultimate couch potato? Is that skunk a little stinker? Whatever its personality, try to capture the special trait that defines the animal. And, as with portraits of people, often the candid, rather than posed, shot is the best. (And don't even think about posing that skunk.)

Be careful using a flash when photographing an animal. The flash may make the animal uncomfortable and even scare it. Try to capture the animal in natural light, if possible. Interestingly, whereas shots of people may incur red-eye from a flash, shots of animals usually incur *green-eye*, which may be harder to remove in editing.

If the animal you're photographing has very dark or very light fur, you may need to slightly underexpose or overexpose the shot, respectively, to retain detail in the fur.

Similarly to the process you use when photographing an athlete, you may need to shoot with a fast shutter speed (check your camera's Manual mode capability) or in Sports mode, which selects a fast shutter for you.

Many cameras have a Continuous, or Burst, mode. In Burst mode, the camera takes multiple photos while you hold down the shutter button. Cameras differ in how many photos are taken and the amount of time between photos. For subjects that move, especially animals and people at play, you're almost certain to capture at least one photo you like from the series. Burst mode may be wasted on a subject that isn't moving, although you may capture an important but subtle change in the subject.

If you're shooting through glass at home, at the zoo, or from your car, find a clean spot and get as close to the glass as you can. To eliminate reflections, some cameras have a *lens hood* that extends a couple of inches beyond the lens. And, if it's available, include some natural surroundings with the animal to give the photo context.

Documenting Events

From time to time, you may find yourself taking photos in a structured, organized, or more constrained setting, such as a sporting event, wedding, or group meal. The good thing about shooting a scheduled event is that you know in advance when and where people will be and what they are likely to be doing at a given moment.

The challenge of taking photos for an event, of course, is that most events restrict your movement and your freedom to use a flash or yell "Stop!" Think about the event ahead of time and recall similar events and the photos you took or have seen from these events. Plan ahead and remain flexible — remember, the unplanned photo is very often the most interesting.

 During an event is not the time to wonder how a particular camera mode works or "what was the difference between aperture and shutter speed?" Do your homework and come prepared. Have lots of space on your memory card (or take spares) and some extra batteries. Practice changing batteries or cards as quickly as you can. You want to be free to think about composition, not mechanics.

Games, sports, or other events with quick action require specific preparation. Weddings, on the other hand, tend to unfold at a much slower pace. But remember that neither event offers the chance to pause or redo.

Freezing action

One of the great benefits of digital *video* cameras is that you can relive every minute of a game or other event. Usually, there are moments that stand out above all the rest. In those moments may be found the best photos of the event.

How do you capture the bat meeting the ball, the goal, or the spike with a regular digital camera, however? With preparation, a fast shutter speed, and some luck.

 Most cameras have a Sports mode that increases the shutter speed and adjusts all other settings automatically. (Look for an icon of a golfer, a runner, or a ball.) Take advantage of

Sports mode and remember it in other circumstances that require quick captures (such as photographing wildlife).

Here are some things to consider when you want to freeze the action in a shot:

- ✔ **Have a plan.** Know in advance what kinds of shots you want to get. Of course, being familiar with the event or sport helps you determine which shots would be most interesting to capture.

- ✔ **Position yourself in the best location to capture the action.** This location may vary as the game, activity, or time of day progresses. In general, keep the sun at your back.

- ✔ **Use a telephoto or zoom lens to help you get close to the action.**

 A monopod (similar to a tripod, but with only one leg) is extremely useful when you're using long, heavy lenses. It's lightweight and almost as steady as a tripod, but you can move it easily to chase action subjects.

- ✔ **Be in the right place at the right time.** Sometimes, timing is so critical that capturing that excellent shot means pushing the shutter just before the perfect moment. Take into account any delay between click and capture (*shutter lag*) your camera has.

- ✔ **Be aware of the background and elements around your focal point.** Unless they add context, keep them simple and nondistracting.

- ✔ **For most sports, shoot at a fast shutter speed (¹⁄₅₀₀ second or faster).** Set your camera to Shutter Priority mode so that if the light changes, the shutter speed stays the same and the aperture adjusts accordingly.

Figure 5-5 shows a frozen instant, full of the action of the game.

Remember that some events don't allow you to use a flash. When you're shooting in low light without a flash, try moving to a higher ISO setting. Just be aware that this may add noise to your images.

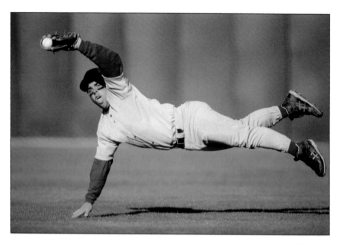

Photo credit: Corbis Digital Stock

Figure 5-5: Be aware and capture the perfect moment.

When you're trying to keep up with a player on the move, give these settings and techniques a try:

- **Set your camera to continuous Auto Focus mode.** This mode gives you better capability to track a moving player.

- **Conversely, try Manual Focus mode.** Auto Focus may be fine for the subject you're capturing, but becoming comfortable with Manual Focus can help you get a shot when Auto Focus falls short.

- **Keep the camera on the player and adjust the focus continuously (called *follow focus*).**

- **Anticipate and focus on the area you expect the action to move into (the *zone focus*).**

- **Try panning.** Using a slower shutter speed, follow the action and press the shutter while still moving the camera. The moving subject remains in focus as other objects blur. This technique creates the illusion of movement in a photo.

Figure 5-6 shows skaters catching some air. (Do the buildings add or detract from the photo?)

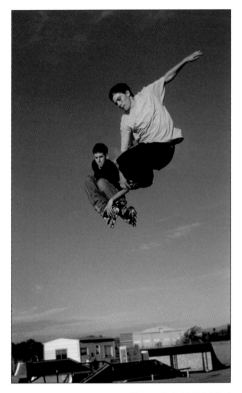

Photo credit: Corbis Digital Stock

Figure 5-6: Use zone focus and shoot where the action will be.

Don't forget to take some shots of the event preparations, the sidelines, the crowd, individual spectators caught up in the excitement, and the aftermath. Sometimes the most interesting and poignant shots aren't even part of the official action.

Photographing a birthday, graduation, or wedding

Many events that you attend are highly structured and chore-ographed, with multiple players performing scripts as beam-ing witnesses look on, often through tears of joy. These events

mark transitions in people's lives, from youth to old age, from school to real life, from two into one. We want to preserve and treasure these moments forever.

But don't let the pressure of the special day get to you. Plan, prepare, know your camera, and stay flexible and alert to the moment. Be prepared with charged batteries, memory cards, and other equipment, such as lenses and a tripod, ready to rumble.

Plan some of your pictures in advance. Know when special moments will happen — blowing out candles on a cake, handing out diplomas, the big kiss. Remember that sometimes the best shots are the candid ones — someone adjusting a formal outfit, a friend or family member radiating pride, or someone goofing off. Keep in mind that discretion is the key at a formal event. No one wants to be haunted by some misbehavior caught on camera.

Scout out the best locations and vantage points for your photos. Minimize the distraction you create for participants and guests. Stay out of the way — and out of the frame — of other photographers, if possible.

Shoot a few throwaway shots to test the lighting. Use a flash only if it's allowed. If it is, consider using a flash diffuser to soften the light. If flash isn't allowed, open the aperture to a wide setting.

Remember the relevant tips in Chapter 4, such as getting in close, eliminating background clutter, composing with the Rule of Thirds, shooting at angles, and finding the light. (Also refer to the section "Getting the group," earlier in this chapter.)

Figure 5-7 shows a candid scene of two people lighting candles on a birthday cake.

Taking in food

Although we often wolf down food at the sink, at our desk, or in the car, a meal shared with others can be an event in itself. And most events feature food and drink. Food can be beautiful by its nature or its preparation. The satisfaction we experience from good food in good company can be the subject of good photographs.

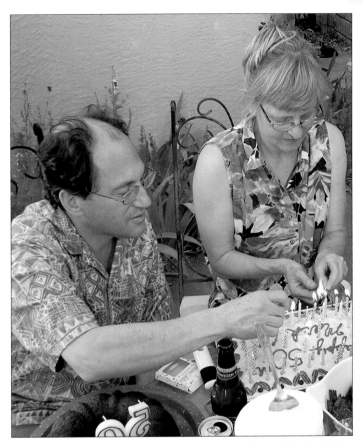

Photo credit: Mark Justice Hinton

Figure 5-7: Anticipate candid moments.

You may want to photograph the food itself, the preparation, presentation and service, or the diners (with permission, of course).

When photographing food, consider the following:

✔ **Take time to set up a pleasing composition.** Think of the food in terms of color, shape, texture, line, and so on. If you have time and are involved with the preparation, set up alternative arrangements for your shot.

✔ **Use simple props.** When appropriate, props can help "set the stage" and give context to the food. Think of your setup as a still life.

✔ **Shoot it quickly.** Capturing food is all about getting the shot before the food starts to deteriorate or change temperature.

✔ **Get close to the food and shoot at plate level or higher.** One technique you may want to try is to shoot with a Macro mode or special macro lens, focusing on one part of the dish and letting the surrounding elements blur. This technique provides a strong focal point while still maintaining the context.

Figure 5-8 emphasizes the dish but provides the larger context of breakfast.

Photo credit: Digital Vision

Figure 5-8: Use simple props to give food context.

Figure 5-9 uses a macro lens to emphasize the moment of celebration. Eat, drink, and be merry.

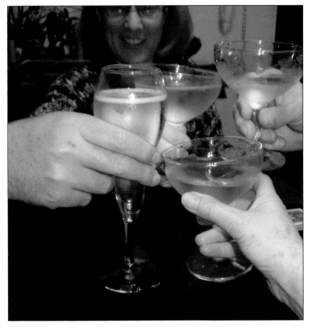

Photo credit: Merri Rudd

Figure 5-9: A macro lens is used here to emphasize the champagne.

Food stylists all have their secret tips for making food look great. You hear stories about using shaving cream instead of whipped cream, airbrushing food with paint, and so on. Additional appetizing tips are to brush vegetable oil on food to make it glisten and to spray water on bottles to make them look wet and cold.

Picturing Land, Sky, and Sea

Few subjects are larger than the earth. We are tiny on the landscape and in the face of the extremes of weather. The environment is a subject of great power, impact — even threat — as well as stunning beauty.

The scale of the land, sky, and sea, and the quick changeability of the weather bring different challenges and opportunities to a photographer. Too often we race over the land, not even turning our faces toward the sun, wind, rain, or land around us. A key to photographing landscapes is to stop and be there in that place.

The great outdoors — and this includes urban settings — invites a sensitivity to scale and distance. Be ready for night-time and bad weather, as either a subject or a challenge.

Shooting landscapes and vistas

Landscapes, including the sky and bodies of water, are great subjects for photography. One challenge is conveying great distance and space in the small frame of most photographs. In your landscapes, be sure to include objects with familiar scale — animals, people, dwellings, or vehicles. You can enhance the depth of the seemingly infinite sky, for example, by including clouds, mountains, or even skyscrapers in your shot. Similarly, the vast sea might be only a puddle until you include a ship or a surfer.

Figure 5-10 uses a person to convey the scale of the scene. In this scene from Seedskadee, along the Green River in Wyoming (the name of the wildlife refuge alone makes it worth photo-graphing), note the leading lines drawing the eye from the lower left to the center right.)

Composition is the element that separates a memorable land-scape shot from a mundane one. Check out the composition tips in Chapter 4, which explain how to use a focal point, the Rule of Thirds, framing, and leading lines. In that chapter, you also find out the basics of including a foreground, middle ground, and background, and shooting from different angles.

To capture expansive vistas, a wide-angle lens serves you well. A zoom lens is a wide-angle lens when it's not extended. As you zoom toward telephoto, you sacrifice width and depth for the sake of getting close to the subject. For example, if you take two shots of a mountain peak — one using a wide-angle and the other zoomed in tight — each type of photo will show something different. Likewise for a photo of someone on the beach: The wide-angle version is very different "zoomed out," showing the context; its opposite, the telephoto shot, is zoomed in emphasizing a part of the whole.

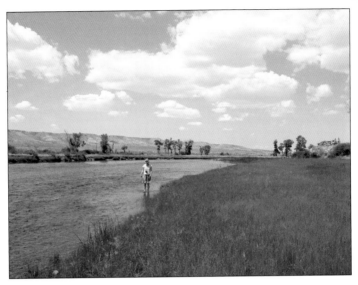

Photo credit: Mark Justice Hinton

Figure 5-10: Include people, animals, or other recognizable objects for scale in vast scenes.

If one shot can't take in the entire scene — or, if you want a 360-degree view — try capturing the scene in several shots and then stitching them together later using a photo editor's Panorama feature. Some cameras also come with software to assist you in creating panoramas. (See Chapter 8 for tips and techniques on creating a panorama.)

Here are a few more ideas to keep in mind for shooting scenery:

> ✓ **Go for the maximum depth of field (see Chapters 3 and 4).** Use a small aperture setting and a slower shutter speed (unless you're working in very bright daylight). Note that many cameras have a Landscape mode that will set up your shot for maximum depth of field and set shutter speed automatically. Keep a low ISO setting for noise-free images. (As mentioned earlier in the chapter, ISO settings refer to how sensitive the image sensor is to light.)

> ✓ **Use a tripod and self-timer or shutter release for the sharpest image.**

✓ **If you're shooting water, include reflections of land-scape features, animals, or people.** Moving in relation to the reflections may enhance them.

✓ **Shooting at dawn (and immediately afterward) and dusk (and just before) gives you soft, warm lighting.** Stormy skies make dramatic backdrops. If you have a boring sky, try a polarizing filter on a DSLR for added color and contrast, or keep the horizon line high to minimize the amount of sky in the shot.

The photo of a sunset in Figure 5-11 (taken at the Bosque del Apache National Wildlife Refuge in New Mexico) uses the setting sun reflected in water to create contrast and bathe the scene in warm color.

Photo credit: Mark Justice Hinton

Figure 5-11: Dusk provides warm, soft, yet dramatic lighting on any object, including water.

Working at night

Taking photos at night requires special settings to increase the aperture (letting in more light at one time), reduce the shutter speed (giving more time for exposure), and, possibly, increase the ISO (providing more sensitivity to exposure).

Your camera may handle these settings effectively with a Night Sky mode (look for a crescent moon or star symbol). You may choose to alter any or all of these settings manually.

You can change one setting manually and allow the camera to adjust the others by using Shutter Priority or Aperture Priority. You can change multiple settings with Program mode or Manual mode.

Figure 5-12 shows a tent in the dark. The slow shutter speed allows time for sparks to trace lines.

You may also need to set the focus manually if the light is too low for Auto Focus to work. To shoot the sky or horizon, set the focus to Infinity.

When you're shooting at night, the camera needs a bigger, more open aperture (at least f2.8), reducing the depth of field. The shutter needs to stay open longer (⅓₀ second or longer). Recall that objects in motion are more likely to blur at slower shutter speeds. If you want to use a faster shutter speed, increase the ISO setting. Just keep in mind that the higher the ISO, the more *noise* your image may contain, lessening the sharpness of the image.

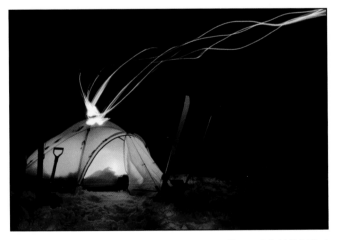

Photo credit: Corbis Digital Stock

Figure 5-12: Night shots usually require a slower shutter speed and a tripod.

To ensure the best night shots, you definitely need a tripod because you need a longer exposure. Use a self-timer so that pressing the shutter button doesn't cause shakiness in your image.

Remember that a flash helps only if your subject is directly in front of you and within range (typically 3 to 12 feet).

Start shooting before dark. Try taking shots at dusk or soon after. Capturing neon lighting is especially nice before it gets really dark and a little natural light is left.

In Figure 5-13, a little extra light shows the neon in context.

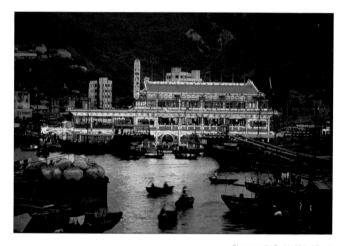

Photo credit: Corbis Digital Stock

Figure 5-13: Shoot neon lights before the evening gets pitch black to show the context.

Weathering the storm

Stormy weather might ruin your vacation or it might give you unusual and dramatic photographs. Even if rough weather doesn't inspire you, it shouldn't inhibit you if you need to get a particular shot.

Take advantage of bad weather's creative benefits. Clouds diffuse the light and eliminate harsh shadows, making for nice landscapes and even portraits. Stormy skies create dramatic backdrops for landscape shots or singular objects, such as trees

or barns. Rain enhances colors and adds texture and reflections on surfaces. If the scene is gray, include a spot of color. Dark objects and colors against white create exaggerated contrast.

Figure 5-14 shows a hiker in a storm in Conejos, Colorado. The hail may not be visible in a smaller print, but the light, the rain gear, and the hiker's posture speak volumes.

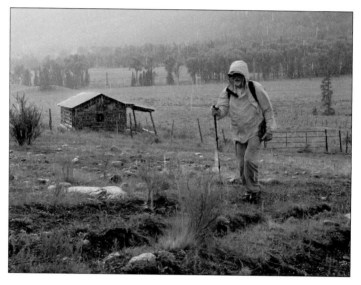

Photo credit: Mark Justice Hinton

Figure 5-14: Life isn't all sunny. Harsh conditions highlight strength and drama.

Bad weather usually means less light. Make sure that your camera is capable of having a wider aperture, longer shutter speed, or both. A tripod keeps images sharp, especially for longer exposures. A self-timer can also be handy. In extremely cold weather, keep a spare battery or two warm in your pocket. Cold weather zaps battery life.

Your camera may have an option to *bracket* shots. This means that when you take one photo, the camera will take several, each with settings one step up or down from the settings you choose. Bracketing increases the odds that you'll get a photo under difficult exposure conditions.

Snow and fog may confuse your camera's light meter, so play it safe and bracket your shots. If your camera has a Snow mode,

use it and play with shutter speeds to capture falling rain or snow.

While you're at it, though, be sure to protect your equipment. Keep your camera as dry as possible by tucking it inside your coat or shirt when you aren't shooting. Keep a soft, scratch-free cloth in your pocket to wipe off any water that gets on the camera. Going from extreme cold into a very warm environment can cause condensation to form in your equipment, so allow your equipment to warm up gradually under your coat; then, put it in a camera bag before you enter a warm room. Finally, make sure all your equipment is dry before you put it away.

Figure 5-15 shows an urban scene transformed by snow.

Photo credit: Mark Justice Hinton

Figure 5-15: Ordinary objects look extraordinary in snow.

Part III
Managing and Editing Your Photos

The 5th Wave — By Rich Tennant

Principal

"I found these two in the multimedia lab morphing faculty members into farm animals."

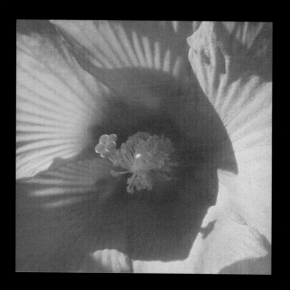

In this part . . .

*W*hen you fill up your camera's memory card, then what? You'll want to move your photos from camera to computer for many reasons, including the convenience of viewing them on a large screen, and this part tells you how to do that. We also tell you about various ways to organize your photos for easy access later.

You can change any photo — for the better, with any luck — by editing it. With the special tools and adjustments available to you in photo-editing programs, you can draw more attention to the subject or fix exposure and color deficiencies, among other things.

6

Transferring and Organizing Your Photos

*A*fter you've been taking pictures for a while, you'll want to transfer the photos from your camera to your computer so that you can edit, share, print, or simply store them. (And, it's definitely preferable to throwing the camera away because it's full.)

After you move the pictures to your computer, you can free up space on the camera for more photos . . . and the vicious cycle begins. That cycle never really ends, and it can eat up more and more of your computer's hard drive space. Photo files are typically megabytes in size. A few hundred photos can add up to a gigabyte of disk space in no time. Consider investing in an external hard drive that is larger than you can imagine using. (An external hard drive is much more convenient than storing photos on DVDs or CDs.) Drives and disk space, like closets and garages, seems to fill up when we aren't looking.

With photos on your computer, you can enjoy all the effort you've made taking those pictures. The photos on your computer are

instantly available for viewing individually, as slide shows, and as screen savers.

This chapter helps you organize your photos. We show you how to use the free tools available to most camera and computer owners. If you want a more full-featured editing tool, you can purchase one of the many alternatives, including Adobe Photoshop Elements, which we introduce in Chapter 8.

Organizing before You Start

Before you copy any photos to your computer, think about how you want to organize those files. Even if you're using a tool that automatically copies photos, you have to configure that tool to serve your sense of order.

It's important to recognize that your organizational style is unique and also likely to change over time. When you can't find that one picture you want most, you may have to let it go. But learn from that search as you copy more and more pictures to your computer, and continue to refine your photo organization skills. Consider what changes to your system will make it easier to find pictures the next time.

How you name the photo files and the folders they go into is very important for organizing and re-organizing photos. Think about whether you should include some descriptive text, such as *vacation* or *Colorado vacation*. And is it helpful to include some part of the date in the file or folder name?

A newer tool called a *tag* offers a way for you to add descriptive categories to your photos, providing further means of organizing your files so that you can easily find them later with a simple search.

Naming files

Your camera names each photo file as it creates it. That name usually includes a sequential or random number or the date and time. Your camera's setup menu may allow you to select the method you want to use for naming files.

Filenames also include a three-letter file *extension* — the three additional letters that follow the period (.) in a filename. The

extension is determined by the file format you select in the camera's setup menus. Most likely, the file extension used for your photo files is .jpg.

If you use an automatic process to copy your photos from camera to disk, that process may rename those files according to options set within that program.

So which is a better filename: DSC0047.jpg or vacation.jpg? *Vacation* may seem to be the better choice if you take only one vacation and save only one photo from that trip. But think through the kind of overall file-naming scheme that might work for you.

Figure 6-1 shows some photos as extra-large thumbnail images (or icons) on the right and folders on the lower left in Windows Explorer in Vista. The photos on the right are sorted by the date they were modified. The gap in the sequence of filenames is either due to deletions or to the date these files were modified. The extension name (.jpg) is normally hidden in Windows. The folder *path* appears at the top of the screen.

Pictures ▶ Latest ▶ 2008-07

Figure 6-1: The sequential, camera-generated filenames matter less in this organizational style than folders and tags.

How you name your individual photos is important, and the addition of tags can help you create an efficient naming scheme. But first, you want to create folders to hold specific photo files in an organized, logical way for easy access in the future. The next two sections help you create folders and then add informational tags to your photo files.

Using folders

The best way to organize groups of files is to create folders in which to store them. Some people also create folders within folders (called *subfolders*). A folder's name should help you recognize its contents as you shuffle madly through, looking for the vacation photos from three — or was it four? — years ago.

For example, you might have the following series of folders within folders:

```
Pictures
    2009
        Vacations
            South Pacific
            Hawaii
```

Or maybe this simpler structure makes more sense:

```
Pictures
    Hawaii
```

As you name folders, keep in mind how your computer displays folders: generally, sorted either by name or by the date modified, although other options are available.

Tagging photos

Imagine that you've just gotten back from vacation with dozens, or even hundreds, of photos. You copy these photos to your computer's hard drive and into a folder created especially for those pictures. Some of those photos include you, others include a significant other, and some include both of you.

The next vacation comes and goes, and the process repeats. Now you can go to the folder for either of those vacations and relive the restful or exciting moments.

But what if you want to see only the pictures of your signifi-
cant other from both vacations? This is where tags come in.
You apply tags to your photos; then, after you have them
tagged, you can view all the photos with a given tag regardless
of the folder location. In this example, you could apply three
simple tags — me, other, both — to quickly display photos in
the three different groups, almost as though you're looking at
three separate photo albums. In this case, though, you have
to store only one version of each photo. Other tags for this
example might include *vacation,* the location (country, state,
or city), or both of these as separate tags.

Tags do not replace filenames and folder names, but they do
provide a very flexible way to categorize photos regardless of
filename or folder location. One photo can be tagged multiple
ways, putting that one photo into multiple categories.

Figure 6-2 shows how tags appear down the left side in
Windows Photo Gallery, a photo organizer included with
Windows Vista. (See the sidebar, "Choosing a photo organ-
izer," later in this chapter for more information about photo
organizers.)

Figure 6-2: Use tags and subtags to organize files regardless of their
location in folders.

Tags can have subtags, such as

```
rockies
    Wyoming
```

shown in the figure. Or, on your hard drive, you might have a series of tags and subtags like this:

```
Flowers
    Roses
        Pink
```

or

```
Europe
    England
        London
```

If this last group of tags and subtags appears in your Windows Photo Gallery list, for example, you can click the *Europe* entry from the list, and all photos tagged *Europe* appear in the window on the right. If you want to see only those photos you took in London, you can click the *London* subtag from the list, and only London photos appear on the right. Tags give you lots of flexibility in finding and displaying specific photos.

 In Windows Photo Gallery, one way to tag photos is to drag a specific photo from the window where it appears on the right and drop it onto an existing tag on the left.

Tags are an example of *metadata*, which is simply the data that describes a file. Other metadata includes the date the picture was taken and all the exposure data (ISO, aperture, shutter speed). Much of this metadata is created and changed automatically. Tags, titles, captions, descriptions, author (photographer), and copyright are some examples of metadata that you can add and change anytime if you have the right tools, such as those discussed in the upcoming sidebar, "Choosing a photo organizer."

Figure 6-3 shows metadata in the Properties dialog box for a selected photo; you can also see this information in the Details pane along the bottom of the screen in Windows Explorer in Vista.

Figure 6-3: You can access tags and other metadata from more than one place.

In Windows, if you right-click a photo file and choose Properties and then the Details tab (choose Info on the Mac), you can see and change metadata. In Windows Vista, you can also see and change some metadata in the Details pane that appears across the bottom of Windows Explorer. Windows Vista and XP users may want to download Microsoft's free Photo Info tool from www.microsoft.com/downloads/ for access to more metadata.

Remember that you have to add tags to photos yourself. The software you use to copy photos from your camera to your computer may enable you to add tags as the files are copied. You can add and remove tags later, but don't wait too long. Just a little discipline in early organization pays dividends later. For one thing, you won't have to try to remember just where in the world you snapped that photo.

Some photo organizing programs enable you to add tags, descriptions, and even ratings with stars. Before you invest too much effort in tagging, however, check to see that the tag stays with the file. That way, if you send the photo to someone else, he or she gets the tag as a part of the data. Some tools create a separate file for this data, or even use an internal database to hold this information. Such data won't travel

with the photo. To test this, tag a photo and send it to a friend. (See Chapter 9 for details about e-mailing photos.) Does your friend see the tag when he views the photo in his photo organizer or in the Properties dialog box when he right-clicks the photo?

Getting Pictures out of Your Camera

You can connect most cameras directly to a computer by using a USB cable and the ports on the camera and the computer. The port on your camera could be just about anywhere on the camera body, and it may be hidden by a small door or cover. Plug one end of the cable into the camera and the other end into the USB port on your computer. Turn the camera power on, if necessary.

In most cases, the computer automatically recognizes the camera and begins copying photos from the camera to the computer.

If your computer doesn't recognize the camera and nothing begins happening automatically, you may need to install a *driver*, a program that tells the computer how to talk to hardware. Odds are that using a driver won't be necessary, though. If manually installing a driver does turn out to be necessary, you may find that a CD containing the driver software came with your camera. If not, go to the camera manufacturer's Web site and download and install the latest driver for your specific camera model and your specific computer operating system (Windows, Macintosh, or Linux).

When you're traveling, take the USB cable so that you can transfer photos from your camera to your laptop or a friend's computer.

Some cameras use a *dock* (a small base) to connect to the computer. A few memory cards or cameras even connect wirelessly to a computer.

To get your photos from the camera to the computer, you can also use a *card reader*. This is a separate device that plugs into your computer. You remove the memory card from the

camera and insert it into the card reader. Just like when you connect the camera directly, inserting a memory card in a card reader should start the copying process automatically. Card readers aren't as common as they used to be because more cameras now have a built-in USB port.

Deleting photos from your camera manually

Despite your blossoming photographic skill, you'll eventually take some pictures that just aren't worth keeping. You can delete pictures directly from your camera's memory card to free up space for newer pictures.

To delete photos directly from the camera, you don't need a computer or a cable. Using the camera's LCD, switch to Review mode (or Preview mode) — look for a button that shows a right-pointing triangle. In Review mode, use the right- and left-arrow buttons to move through a display of your pictures. When you find a photo you don't want to keep, press your camera's Delete button (look for a trash can icon) or a Delete menu item. Some cameras require confirmation of the delete instruction.

Okay, now that we've told you how to dump that picture from your camera — don't do it! It's just too easy to delete the wrong picture. And you can't judge a picture completely on the tiny LCD. You need to see it on your large computer monitor. Perhaps the picture has details worth cropping (see Chapter 7). Perhaps you can improve the picture with other edits (make it lighter or darker, among other possibilities).

Many people delete a photo thinking they'll take a better one later — but they never do. Even a bad picture might be better than no picture at all. So transfer that photo to your computer, review it there, and think twice before dumping it.

 Get a memory card large enough to hold all the pictures you might take before you have a chance to move them to the computer. See Chapter 1 for more about memory cards and photo file sizes.

To get rid of every photo on the camera in one step — are you sure you want to do this? — use the camera's setup menu to format or erase the memory card. There is no Undo for

formatting or erasing a memory card. So be very sure that this is what you want to do. Again, *you can't undo this!*

Copying photos from your camera automatically

In most cases, connecting a camera to a computer automatically starts the copying of pictures from the camera to the computer.

With the pictures safely on your computer, you can delete them from the camera without regret. In fact, the automatic copying process probably includes an option to automatically delete all pictures on the camera after the copying completes successfully. Take advantage of that automatic delete — it will save you time.

Your camera may come with software for moving, organizing, and editing your pictures. Before you install more software, see what happens without that software. You may already have everything you need for basic tasks.

The following steps show you how to use Windows Photo Gallery, which comes with most editions of Windows Vista, to transfer photos from your camera to your computer. But you can use any photo organizer. See the sidebar, "Choosing a photo organizer," in this chapter for more information on what other programs are available.

1. **Connect your camera or card reader to your computer by using a USB cable.**

 Alternatively, if your computer has a media card slot or you have a card reader, insert your card. If your camera has a docking station, plug it into your computer and place your camera in the dock.

2. **Choose from one of these options:**

 - *In Windows Vista, the computer detects the connection.* The Autoplay dialog box may appear and ask what you want to do with your images, or one of these functions may start automatically.

 Choose the Import Pictures command to import your images. You may see separate Import options

if you have more than one photo organizer installed. Choose the photo organizer you want to use. Import pictures using Windows will automatically use Windows Photo Gallery.

Choose the Open Folder to View Files command to launch Windows Explorer and display your camera or memory card as an attached disk.

Note that if you have Adobe Photoshop Elements installed, the Adobe Photo Downloader may pop up instead of the Autoplay options. Just click Cancel if you don't want to use it. Other photo organizers may also automatically copy files from the camera.

- *You installed software that came with your camera.* If you prefer to use that software, follow that program's documentation for transferring your photos.

- *You are using a Mac.* iPhoto may automatically open to provide tools for working with the photos on your camera. The computer sees your camera or reader as another drive on your computer. Double-click the icon and then the folder, and Option+drag the images you want to keep to another folder on your desktop.

Copying photos from your camera manually

Ideally, when you plug your camera into your computer with a USB cable, your computer automatically copies your pictures from the camera to your computer's hard drive. However, when your camera is attached to your computer, the camera's memory card is listed as a removable disk in Computer (or My Computer if you're using XP). On a Mac, this removable disk appears as an icon on the desktop. You can browse that disk as you can any other, working your way into the folders to find the individual photo files. From there, you can copy, move, and delete files. Avoid renaming files still on the camera because renaming them may interfere with the camera's own automatic naming function.

Choosing a photo organizer

Digital photography is so mainstream these days that most computer operating systems include support for many photo-related tasks.

Most photo organizers allow you to browse photos from anywhere on the system, regardless of the specific folders those photos are in, as if you are looking at one huge photo album. Those photos can be sorted and grouped by date taken, date modified, file or image size, location, tags, anmore.

Photo organizers make it easy to add tags, ratings, titles, and notes to your photos. See the section "Organizing before You Start," earlier in this chapter, for more on tags.

Photo organizers typically include tools for basic editing, including cropping, brightness, and contrast adjustments. (See Chapter 7 for more about editing your photos.)

Photo organizers also provide tools for printing, e-mailing, and uploading your photos to the Web. (Chapter 9 tells you more about sharing your photos.)

Here are some of the available photo organizers:

✔ **Windows Photo Gallery (WPG):** WPG is included with most editions of Windows Vista. WPG displays all the photos and movies in the Pictures and Videos folders by default, as well as any subfolders under those locations. (You can add other folders from any location on your computer.)

✔ **Windows Live Photo Gallery (WLPG):** WLPG is an upgraded version of WPG that is free for Vista and XP systems. WLPG adds a few editing tools to those in WPG, such as photo resizing and detail sharpening. You can download WLPG from `http://get.live.com/`.

✔ **Picasa:** Picasa is an organizer and editor from Google. You can download it from `www.picasa.com`.

✔ **iPhoto:** The Mac includes iPhoto as the photo organizer and editor in the iLife suite.

✔ **Adobe Photoshop Elements (APE):** Elements is a limited edition of the powerful, professional Adobe Photoshop. Both programs differ from the other programs listed here in that they have more extensive editing tools and aren't free. You can download a 30-day trial version from `www.adobe.com`. (See Chapter 8 for an introduction to APE.)

Follow these steps to manually copy or move photos from the camera to the hard drive:

1. Connect your camera to your computer by using a USB cable.

If your computer has a media card slot or you have a card reader, insert your card. If your camera has a docking station, plug it into your computer and place your camera in the dock.

2. **Choose from one of these options:**

 - *In Windows Vista, the computer detects the connection.* If copying starts automatically or any dialog box appears automatically, see the "Copying photos from your camera automatically" section earlier in this chapter.

 Choose the Open Folder to View Files command to launch Windows Explorer. Alternatively, you can launch Windows Explorer manually by clicking the Start button and choosing Computer.

 In Windows Explorer, select Computer (or My Computer in XP) to display all disks, including your camera or memory card. Select the camera folder containing your images, select the ones you want, and copy them using drag and drop or by pressing Ctrl+C. Then choose the folder on your hard drive in which you want to place your photos. In the folder, press Ctrl+V to paste the photos into the folder. Filenames will remain the same as they are on the camera unless you manually rename the files.

 - *You are using a Mac.* The computer sees your camera or reader as another drive on your computer. Double-click the icon and then the folder, and Option+drag the images you want to keep to another folder on your desktop.

Viewing Your Photos on Your Computer

One of the primary reasons for transferring your photos to your computer's hard drive is so that you can view them anytime you like. You can view photos individually or in slide shows, assuming that you can find the photos you want.

In this section, you use any photo organizer you want to find specific photos and view them in a slide show. Refer to the earlier sidebar, "Choosing a photo organizer," if you need help

selecting one. You might even try a couple of different ones to compare them.

Finding photos

If you have organized your folders unusually well, you can put your virtual finger on any photo by stepping through those folders using Windows Explorer (or Finder, on the Mac). A few clicks and you have that photo you took three years ago.

Unfortunately, even the best organization fails most people from time to time. Opening 20 or 50 folders to look through hundreds of photos isn't much fun. There are alternatives to hunting.

Fortunately, the operating system (OS) on your computer has built-in search tools. Windows Vista has Windows Search; the Mac has Spotlight and Finder. The latest search functions in Vista and Mac can search metadata such as tags, camera name, or other text associated with the picture, as well as by filename. (See the "Organizing before You Start" section, earlier in this chapter.)

Photo organizers also include search functions for searching by name, date, tag, and other metadata, as well as sorting files by date taken and date modified.

In Windows Vista, you can search directly from the Start menu or from the upper-right corner of Windows Explorer. With the cursor in Start Search on the Start menu or in the Search box in the upper-right corner of Windows Explorer, type part of the filename or a tag or other metadata for the photo you want to find. Matching files from the current folder in Explorer or from all your folders, in the case of the Start menu, appear automatically as you type. For more information on Windows Vista and Windows Photo Gallery, see *Windows Vista For Dummies*, by Andy Rathbone (Wiley Publishing) or *PC Magazine Windows Vista Solutions,* by Mark Justice Hinton (Wiley Publishing).

Looking at photos individually

Whether you searched for or manually stumbled upon a photo, click or double-click the mouse to open that photo in the default

photo-handling program. This default program may be simply a viewing tool, or it may be a photo organizer or an editor.

If this default program isn't the program you want to use to view your photos, you have to identify the program you do want. In XP or Vista, right-click for other options. If you don't see the program you want listed on the context menu that appears when you right-click, choose Open With. Recommended programs appear in the Open With dialog box. You can also browse from that dialog box to select a program that is not listed.

If the preceding steps don't open the file you want in the program you want, you can start that program from the Start menu and open the File using File➪Open.

After a photo is open, you should be able to move forward and back to other photos through right- or left-arrow buttons on the keyboard or through on-screen buttons.

Figure 6-4 shows a single photo displayed in Windows Photo Gallery. Use the Forward and Back buttons (right- and left-pointing arrows) at the bottom to move either direction, and click the middle button to display a slide show. (See the upcoming section for details on seeing a slide show.)

Figure 6-4: View photos individually.

On the far left of the toolbar shown at the bottom of Figure 6-4, you can click the magnifying glass to zoom in and out on the picture. To the right of the magnifying glass, if you click the tool that looks like a square surrounded by arrows, you can alternate between a photo at full size, which is almost always larger than the screen, and fitting the photo to the screen size so that you can see it all at once. Click to zoom in with either of these tools, and then click and drag on the photo to pan around to different areas. See Chapter 7 for an explanation of the three editing tools at the right end of this toolbar. You may guess that the red X on the far right deletes the photo you are looking at. There is no confirmation message or undo at that point, although you can go to the Recycle Bin to recover the file.

Viewing a slide show

Slide shows automatically move through pictures at a set pace (3 to 5 seconds per picture). Some slide shows allow you to add artsy transitions between the pictures, along with showy borders, backgrounds, and other effects.

You can have a slide show run through every photo on the computer, or you can select photos by location, date, rating, or tag. Open your photo organizer or an individual photo. Look for a slide show button or menu item from the menu across the top or from a context menu that appears when you right-click. Sit back, smile, and enjoy the show.

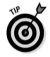

Your computer can use a slide show as a screen saver and automatically display photos when it's idle. In Windows Photo Gallery or Live Photo Gallery, choose File➪Screen Saver Settings. In the Screen Saver Settings dialog box, choose Photos. Use the Settings button to choose between all photos, just those in a specific folder, or those with specific tags or star ratings. You can also choose how long each image stays on-screen and whether you want to include a theme, background, or transition. Click Save when you are done with the settings. Click the Preview button to see the effect of those settings. Moving the mouse or pressing any key clears the preview. When you are finished, click OK.

For information on creating a slide show on CD or DVD, see Chapter 9.

7

Easy Edits and Modest Makeovers

*N*ow that you've been taking photos with your digital camera for a while, you may not always be thrilled with the outcome and may even wonder, "Can this photo be saved?" The answer is often "Yes," even for photos you might at first consider deleting.

In this chapter, you work with several common tools to fix or improve your photos. A photo that isn't quite exposed correctly can be fixed. A photo with composition problems — the subject isn't emphasized or something else in the frame distracts — can be improved. A surprising array of adjustments can take a photo from okay to "wow."

The examples in this chapter feature Windows Live Photo Gallery (WLPG) — a free program available to any Windows user — although the concepts and terminology in this

chapter apply to any photo editor. See the sidebar "Checking out photo editors," later in this chapter, to find out what photo editors are available.

Editing a photo presents an opportunity to consider what you could have done differently when shooting. Look for tips in each section that suggest how you might avoid a specific problem when taking a picture so that you can save time later on editing.

Backing Up Your Photos

Before you make any changes to your photos, take time to back them up. That way, no editing change is permanent — you can recover from any changes or deletions.

You may want to back up an entire folder or all your photos simultaneously by using a backup program. Windows, Mac, and Linux all include backup software. Check the main system menu or search your computer for *backup*. Free alternatives also exist. (Search the Web for *backup software review*.) You can back up your photos to an external hard drive, a USB flash drive, or a CD or DVD. You can even back up to another computer on a network or by copying files to a Web-based backup service. (Search the Web for *remote backup* or *Web-based backup*.)

A backup program has many benefits, including automatic scheduling (daily, weekly, and so on) or archiving (keeping multiple copies of the same file as it changes). Such backup features take time to understand and configure. That is time well spent. You should include all your irreplaceable files in a good backup plan.

However, you can also back up individual files or folders as you think of it or just before you begin to edit. You can manually copy selected files or folders using drag and drop between the original location and the backup location. Or you can copy and paste by selecting the files and right-clicking to open a context menu. Choose Copy from this menu, navigate to where you want to paste the files, right-click again, and this time choose Paste.

You can copy individual photos as you work on them by choosing Save As (or Make a Copy) from the photo editor of your choice. See the sidebar "Checking out photo editors" a little later in this chapter.

All photo editors should allow you to undo edits before you save the file. Some editors enable you to revert to the original, even after saving. The safest thing is to create backups before you begin editing. Backing up is easy to do and may save you from all kinds of missteps, goofs, surprises, and disasters. The insurance of a backup may make you feel freer to experiment and learn.

Checking out photo editors

Most computers come with a prein-stalled tool for organizing and editing photographs. All photo editors provide the basic editing capabilities covered in this chapter.

Photo editors also enable you to convert photo files to other file formats. You may decide to store your files on your hard drive as uncompressed TIFFs, for example, and then convert individual files to smaller, compressed JPEGs to e-mail to friends or upload to the Web. You can do this by choosing File⇨Save As (or Export). Just keep in mind that this process requires extra work and more disk space than simply storing everything as JPEGs.

Some cameras include editing software on a CD or make it available from the manufacturer's Web site. You can also download free and for-a-fee photo-editing software. In most cases, the more editing features a program includes, the more it costs and the more effort you have to put in to learn to use the extra features.

Here are some of the most popular photo editors (all are free except for Photoshop):

⬥ **Windows Photo Gallery (WPG) and Windows Live Photo Gallery (WLPG):** WPG is included with most editions of Windows Vista. WPG is not available as a separate download. WLPG is an upgraded version available for all Vista editions and Windows XP. WLPG has more editing features than WPG.

In both programs, you can select an image in the Gallery and click the Fix button at the top of the screen. (We refer to the Fix button in WLPG in most sections of this chapter.) Both programs automatically save changes when you leave editing, and both allow you to revert to the original after saving. You can download WLPG from `http://get.live.com`.

(continued)

(continued)

- **Windows Paint:** Paint is included with all versions of Windows but isn't available for downloading from the Web. It's a very basic editor, so it might be your editor of last resort. However, Paint makes it easy to add text to a photo.

- **IrfanView:** IrfanView is a wildly popular shareware program for image editing and conversion. It provides tools for editing, converting formats, optimizing for the Web, and batch processing multiple photos. You can download it from `www.irfanview.com`.

- **GIMP:** GIMP is the favorite image editor for Linux, but a Windows version is also available. GIMP has a highly customizable interface, letting you choose which tools to show or hide. You can download it from `www.gimp.org`.

- **Paint.NET:** Not to be confused with Windows Paint, Paint.NET is a powerful photo editor with an active online community

supporting and extending the program. You can download it from `www.getpaint.net`.

- **iPhoto:** iPhoto is the Mac editor included with the iLife suite. You can download it from `www.apple.com`.

- **Adobe Photoshop:** Photoshop is one of the top commercial, professional graphics editing programs. A simpler and less expensive consumer version is Photoshop Elements. (Photoshop and Photoshop Elements are the only editors listed here that you must pay for.) Chapter 8 covers some of the tools you'll find in Elements. You can download Elements from `www.adobe.com/photoshop/`.

You might want to check out the free, online version of Photoshop called Adobe Photoshop Express. Chapter 13 points out some benefits of using Express. You can download Express from `www.photoshop.com/express/`. Did we mention that it's free?

Rotating Photos

When you take a photo, you can hold your camera in one of two orientations: *landscape*, for which you hold the camera normally (as it hangs from your neck strap), and *portrait*, for which you rotate the camera body 90 degrees vertically for a shot that is taller than it is wide. (Okay, you can hold your camera at any wacky angle you like, but landscape and vertical are the conventional angles. Other angles may be brilliant

or disturbing.) When stored in the camera, all pictures have landscape orientation, even portraits.

When you copy photos from your camera to your computer, you have to rotate those portrait photos to turn the image so that it matches the vertical orientation of the original shot. (If you need help with transferring photos from your camera to your computer, see Chapter 6.)

Some cameras record the orientation of the shot in the metadata of the image. Some software can read that information and then automatically rotate the images taken in portrait orientation.

To manually rotate an image, view and select the image in the photo editor of your choice and look for two rotate buttons or menu options to rotate 90 degrees clockwise (right or down) or 90 degrees counterclockwise (left or up). The rotation buttons usually show an arrow curving in the direction of rotation.

Figure 7-1 shows a portrait of three old friends before rotating vertically. The camera was in a vertical position when the photo was taken.

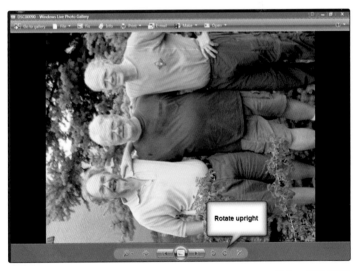

Photo credit: Merri Rudd

Figure 7-1: The camera stores portraits horizontally, so you may need to rotate portraits vertically.

Subjects that are taller than they are wide are naturals for portrait orientation, especially if you want more of the subject and less of the background. However, take some portrait shots in landscape orientation to show the subject in context.

If you rotate too many times or in the wrong direction (everybody does occasionally), simply rotate the other way.

JPEGs usually compress each time the file is saved, tossing out a little more data. If you repeat the process too many times on one JPEG, you start to see defects in the image quality. Avoid this by doing all your edits at one time or by working from an unedited copy of the original file. Image quality degradation is not a problem with uncompressed TIFFs or RAW files. This warning does not apply to rotating JPEGs. Rotating a JPEG repeatedly should not affect its image quality.

Resizing Photos

Your multi-megapixel camera produces high-resolution photos, and you can print high-resolution photos as large prints. (Chapter 10 discusses printing your photos.) You can also crop high-resolution photos and still have reasonable resolution in the remaining area. Cropping is covered in the next section.

These high-resolution photos are big files — sometimes many megabytes in size. They are also big in area — bigger than most computer screens — and you want big photos for printing and editing.

But for e-mailing or posting on the Web, smaller photos may work better. A small file uploads and downloads faster, and smaller files are often easier for e-mail recipients to handle. (Chapter 9 discusses e-mailing and Web-posting photos.) Consequently, you may want to resize some of your photos, and this section shows you how to do just that.

Your camera setup options let you specify resolution. For greatest flexibility, choose a high resolution. (If you need a refresher on resolution, see Chapter 1.)

Look for Image Resize in your editing software's main menus or context menus (brought up with a right-click over a photo).

Generally, you can resize in either pixels or by percentages. When you select an image, some programs display tiny squares, called *sizing handles*, at regular intervals along the sides of an image and in the corners. Click and drag these handles to resize.

During resizing, most programs constrain the settings to keep the reduced image in proportion to the original. (You may be able to override this, but it's likely to distort the image.)

When you save your file after resizing, you may want to use a new filename so that you don't overwrite the larger original, which is still the preferred file for editing and printing.

Figure 7-2 shows the Resize command in WLPG. To resize in this application, right-click a selected photo and choose Resize from the context menu (a portion of which appears beneath the butterflies in Figure 7-2). From the Resize dialog box, click the drop-down arrow at the right end of the Select a Size field and then choose from the list: Smaller, Small, Medium, Large, and Custom sizes.

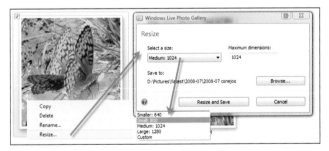

Figure 7-2: Resize your photos to preset or custom dimensions.

If you choose the Custom size, you can specify a number other than the default that appears in the Maximum Dimensions box to the right. This is the maximum for the longer of the two dimensions, whether width or height. The same is true for the numbers that appear in the drop-down menu. You can also change the folder the copy will be placed in by using the Browse button. Otherwise, the smaller file is saved in the same folder as the original. WLPG uses the original filename and adds the width and height in parentheses, as in *butterflies (640 x 480)*. You can resize more than one file at a time by selecting the check box in the upper-left corner of each photo.

Select multiple files and then right-click any one of the images and choose the Resize option.

Photos are often more than 2,000 pixels wide — twice as wide as some monitor resolutions. For e-mail, consider making your photos 800 pixels wide by 600 pixels high as a maximum. For the Web, 1024 x 768 may be a better size.

If you're resizing a photo just for e-mail, you can select a photo in WLPG and click the E-mail button in the middle of the toolbar at the top of the screen. The dialog box shown in Figure 7-3 appears. In this box, you can choose from various options from the Photo Size drop-down list. The box also displays the file size based on your photo size choice. When you click Attach in this dialog box, Windows starts your default e-mail program and attaches the resized file. (The original image file is untouched.)

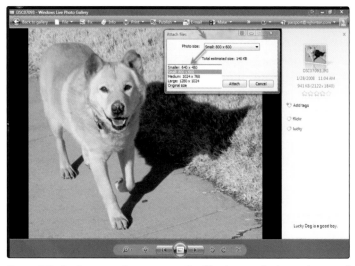

Figure 7-3: Saving your photo to a smaller file size may be better for e-mail.

When you shoot a photo, you can avoid resizing later by choosing a lower resolution in the camera setup menu. Except for file size, however, the highest resolution has all the advantages over lower resolution. So it might be better to shoot with a higher resolution and use a photo editor to resize the photos you want to send through e-mail.

Cropping Photos

You may want to emphasize one portion of a photo or eliminate an out-of-focus or otherwise distracting element from a photo. *Cropping* is the term for selecting a portion of a photo to save while deleting the rest of the photo.

Appropriate cropping is very subjective, as are many of the edits you make to your photos. Tight cropping brings the edges of the image very close to the subject, showing very little of the background or surrounding scene. Looser cropping shows more of the surroundings with the subject smaller within the frame.

Cropping can change the shape of the photo, for example, turning a landscape shot into a vertical portrait or changing the usual rectangular shot into a square. There are vast variations in cropping.

The mood or visual impact of a photo changes with different cropping. You may want to undo and recrop or crop different copies of one original to see the difference.

To crop a photo, view it in any photo editor. In WLPG, select a photo and click the Fix button in the toolbar at the top of the screen. Select the Crop or Cropping tool, which often looks like two overlapping right angles. Click and drag a box over the part of the image you want to keep; everything outside this box will be deleted. You may be able to fine-tune your selection by clicking and dragging the tiny handles around the edges and in the corner of the selection box.

Figure 7-4 shows a composite image of a poisonous Monkshood wildflower. The original photo is on the left with the default cropping box visible, as it appears when the Crop Photo option is selected. With the default, loose cropping has been indicated; most of the background would be tossed, but not all. To the right is a tightly cropped version — a smaller part of the original — which reveals details less visible in the original. Farthest to the right are the Fix tools in WLPG, with the Crop photo option expanded. Click Apply to see the effect of your cropping.

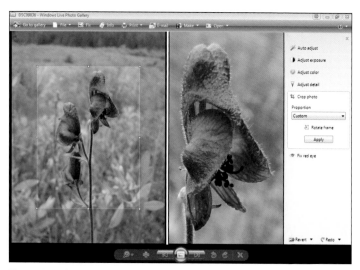

Figure 7-4: Cropping sets the mood and affects the recognizability of the subject or context.

For e-mail and the Web, tight cropping has two benefits:

1. It puts clear emphasis on the subject.
2. It results in a smaller file size.

Keep in mind that if you crop a very small area of a photo or start with a low-resolution original, your cropped image may be too blurred or jagged to be useful.

For cropping, you can't have too many pixels. Buy a camera with high resolution (the more megapixels, the better) and set the resolution to the highest level to maximize your cropping options. The uncropped file, on the other hand, is huge and takes more hard drive space to store and more processing time to copy.

To avoid cropping, take close-ups. Get closer to your subject by moving in or by using a zoom lens. For extreme close-ups, use your camera's Macro mode. You're likely to get the most details with a close macro shot. Take a few wide-angle shots, as well. You can crop a wide shot, but you can't widen a tight shot.

Fixing Red-Eye

Red-eye is the reflection of a flash off the back of a subject's eyes. With human subjects you see a red reflection, whereas animal subjects produce green-eye or yellow-eye. Red-eye is a consequence of having the flash so close to the lens on most cameras. The small distance between the lens and the flash creates a very small angle in the travel of light from the flash to the back of the eye and back to the lens.

Red-eye is most common in close-ups or portraits shot in low light. It is more likely to occur if the subject is looking directly at the camera.

To fix red-eye in the editor of your choice, choose the Fix Red Eye tool (often indicated by a red eye — imagine that). Draw a small box around the red part of the eye, completely enclosing it while trying to enclose as little else as possible. The program then changes red pixels to black, which is why it's important not to include red that actually belongs in the photo.

Figure 7-5 shows an example of red-eye and the Fix Red Eye tool. One eye has been fixed (notice the flash on the glasses) and the other shows the small selection box.

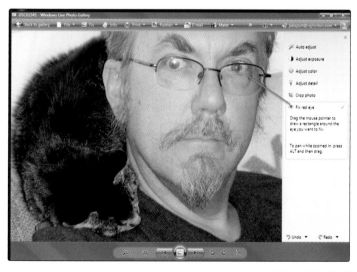

Photo credit: Merri Rudd

Figure 7-5: Use the Fix Red Eye tool to draw a small box over the red eye.

Your camera may have a red-eye reduction function. Usually, this involves two flashes. The first flash contracts the subject's iris, reducing or eliminating red-eye. The second flash is used for the actual photograph. (Some people find this double flash confusing or irritating.) Most non-DSLRs have a fixed flash that cannot be moved. If you can point or remove your flash, try to bounce the flash off the ceiling, wall, or nearby reflective surface. Low-tech solutions include turning up room lights (even removing lamp shades). Also consider having the subject look away slightly.

Adjusting Exposure

Despite your best efforts — or your camera's best efforts — some of your photos may come out too dark or too light. Most photo editors have a one-click auto-adjustment for exposure (brightness and contrast) and color. For photos that need tweaking, try the auto-adjust function. If you don't like the results, you can manually adjust exposure, contrast, or color. Whether you undo the auto-adjustment depends on whether the results of auto-adjust are closer to what you want than the original.

Figure 7-6 is a composite picture of two versions of a close-up of a roadrunner after a bath in a sprinkler. On the left is the underexposed original. Can this photo be saved? Yes! On the right is the adjusted version following changes to the sliders under Adjust Exposure on the right. (Auto Adjust was not used in this case, as you can tell because there is no check mark to the right of that option.) In particular, notice that the ring around the roadrunner's eye shows much more clearly in the edited version. The so-called *original* on the left is actually the result of cropping a photo that showed more of the background. You may need multiple edits to fix some photos.

All photo editors enable adjustments to brightness and contrast. Here are a few other properties some editors include under exposure adjustments:

- **Brightness:** Push the brightness too light, and some areas wash out to white. Push the brightness too dark, and other areas fade to black. The WLPG Brightness slider produces brighter images to the right and darker images to the left.

Adjust the brightness to adjust the mood of a picture. A little darker may make the photo more dramatic; less dark, may make it seem less ominous.

✓ **Contrast:** Contrast is the difference between light and dark areas of the photo. A high-contrast image looks sharp — maybe too sharp. A low-contrast image looks softer and more muted. The WLPG Contrast slider increases contrast to the right and softens it to the left.

✓ **Shadows:** This property refers to those pixels closer to black than white. You may be able to lighten or darken these pixels separately from the lighter ones. The WLPG Shadows slider brightens the dark areas to the right and darkens them to the left.

✓ **Highlights:** This property refers to those pixels closer to white than to black. You may be able to lighten or darken these pixels separately from the darker ones. The WLPG Highlights slider brightens the light areas to the right and darkens them to the left.

Adjusting brightness affects every pixel. Using shadows or highlights adjusts just those pixels that are darker or lighter, respectively. Shadows and highlights are more selective than overall brightness.

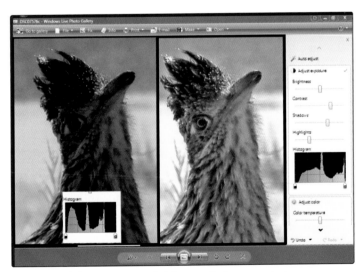

Figure 7-6: Adjust exposure to brighten or darken your photo.

A *histogram* is a graphic display of pixel distribution from dark to light (left to right). Your camera may have a histogram display that either appears live as you compose or displays after the photo is taken. Your photo editor may also have a histogram.

Looking at Figure 7-6, you can see the original photo's histogram is superimposed on the left. That original histogram shows three peaks indicating that most of the pixels are toward the dark end (the shadows to the left) and almost none are toward the light (the highlights to the right). Overall, this is a dark image, and you don't need a histogram to know that.

On the far right of Figure 7-6, the histogram for the adjusted photo shows a more even distribution of dark and light, with peaks near middle exposure and toward the bright end. Truth be told, there is no perfect histogram, or, more to the point, a histogram doesn't tell you that a photo is good or bad. Instead, a histogram is a different way of analyzing exposure. For most people, what you see happening in the picture as you make adjustments is more important than what you can read in a histogram.

Start with your editing program's auto-adjustments and let the editor try to fix the exposure. Then, undo the auto-adjustment or proceed to tweak the exposure by using the sliders or other tools your photo editor provides.

You may avoid exposure problems by adjusting your camera settings. When in doubt, use the camera's Automatic mode. Try different scene modes with a little imagination. For example, Beach mode might be perfect for shooting a snowy scene; both beaches and snowy landscapes are very bright. When in doubt about manual settings, use your camera's *bracketing* function. Look for a menu or button for Bracket. Bracketing causes the camera to automatically take two to four extra photos with minor adjustments to whatever exposure setting you have manually chosen. You end up with a lot of near-duplicates but also improved odds that one will please you.

If you continually over- or underexpose photos, some deeper setting in your camera's setup menu may be causing the problem. Look for an option to reset all settings or take the batteries out to force a reset.

Changing Color

How green was the grass? How blue was the sky? Whether an image captures the true color or not, you can shift color and change the overall dominant color. A deft adjustment of color may make the picture more vivid. The wrong adjustment can show people and scenery in unnatural colors.

Figure 7-7 shows an original between two versions with the color shifted. The color adjustment sliders appear superimposed over each image. The original was the most true, with the lavender shirt and the red binders.

Figure 7-7: An original image between versions that are black and white (left) and pushed unrealistically colorful (right).

All colors are composed of three constituent colors in varying degrees: red, blue, and green. You can adjust these colors

individually or all at one time. Color consists of at least these three separate properties:

- ✔ **Temperature:** Red is warmer; blue is cooler. The WLPG color temperature slider yields more red to the right and more blue to the left.

- ✔ **Tint:** Tint is an adjustment to the effect caused by different light sources. For example, incandescent light bulbs cast a yellowish light, whereas fluorescent lights cast a bluish light. Use tint to shift colors. The WLPG tint slider yields a redder cast to the right and a greener cast to the left.

- ✔ **Saturation:** Saturated colors are rich and vibrant; less saturated colors are paler and flatter. Unsaturated colors are shades of gray. The WLPG saturation slider yields more vivid colors to the right and less vivid colors to the left. Notice that the unsaturated image in Figure 7-7 looks black and white.

Your camera may have more than one color mode. Some cameras have a Normal mode and a Vivid mode that intensifies saturation. You can affect the tint by using a flash indoors. Your camera may have a white balance control you can set to match the light source, such as incandescent or fluorescent, and this changes the tint. Each of these options may be in your camera's setup menu.

Sharpening Edges

Pixels have a limitation: Each pixel represents a single color value. Imagine two solid blocks of different colors side by side with a line between these blocks. Every pixel on one side of the line is one color; every pixel on the other side is the other color. Real life just isn't like that very often. In photos, it is inevitable that some pixels fall directly on a line, with half a pixel on either side of that line. But there are no half-pixels in photography, so those border pixels have to be entirely the color on one side or the other side, or be a blend of the two colors. Digital cameras often opt for a blend as a transition. You don't normally see pixels, so when you look at an entire picture, you usually don't notice this blending or you may see part of the picture as *soft* or not having sharp borders.

This softness isn't really a focus problem, although it may look like one.

The fix to soft edges is to sharpen them. Sharpening adjusts the color of pixels adjacent to soft borders to intensify the border, sharpening the soft edges somewhat (sometimes too much). Some photo editors have a tool for sharpening the details of a photo. Figure 7-8 shows the details of a dragonfly which has countless lines, any of which may be subject to softness.

Figure 7-8: Softness may appear to be a focus problem, but it is a limitation of digital pixels.

Figure 7-9 shows two views of the dragonfly. On the left, the photo is slightly sharper. The head and the left wing look more in focus, although this isn't really an issue of focus but the trouble with pixels, as discussed at the beginning of this section. On the right, the photo is oversharpened to the point that defects, called *artifacts,* appear, especially in the background. This photo looks grainy.

You can't do anything to change the limitation caused by the fact that a single pixel can't represent two colors. However, you can choose your camera's highest resolution during setup to use more pixels, pushing this potential problem into a smaller area.

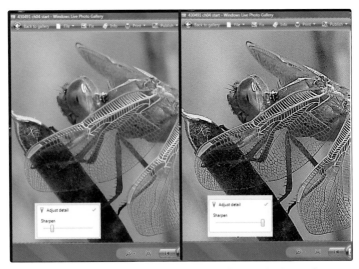

Figure 7-9: Sharpen slightly to improve details. Too much sharpening creates new defects.

Extending Your Editing Power

Previous sections in this chapter discuss some of the great enhancements you can make to your photos using a very basic photo editor that you can get free or for a low price. If you want to invest a little money and some time in learning to use it, however, a powerful photo editor enables you to make amazing adjustment to every aspect of an image. Powerful editors offer more tools to apply changes semi-automatically or completely manually, down to individual pixels. Chapter 8 discusses some of the tools in one of these powerful editors, Adobe Photoshop Elements.

All photo editors include a tool to rotate an image. Basic editors are limited to 90-degree increments, however, which won't help if the camera wasn't quite level and the subject is tilted just a little. More powerful editors enable you to make adjustments in smaller increments.

Simple tools allow you to crop any rectangular area. Powerful tools may enable other shapes, such as circular or free hand.

Basic tools let you adjust exposure for the entire image. More powerful editing tools enable exposure adjustment to selected areas or even down to the pixel level. You can brighten the subject and not the background, for example, or vice versa.

Consider starting with the simplest tools, especially those already on your computer. When your needs exceed the capabilities of those tools, you may want to invest some money and time in more powerful tools. The time you invest in the simpler edits will be useful as you learn more complex skills. See the sidebar "Checking out photo editors" earlier in this chapter.

For more information on editing photographs, see *Digital Photography For Dummies,* 6th Ed., by Julie Adair King and Serge Timacheff (Wiley Publishing), and *Photoshop Elements 7 For Dummies,* by Barbara Obermeier and Ted Padova (Wiley Publishing).

8

Major Makeovers Using Adobe Photoshop Elements

*A*dobe Photoshop Elements (*Elements*, from here on) is a popular program for editing photos that you may already have access to. Elements provides many tools for fixing and improving your photos. Some of these tools are essentially automatic: You click a button for a quick fix. Other tools are very powerful and require careful and thorough selection of just those areas of the photo you want to change.

As is the case with most computer programs, Elements uses menus and toolbars to enable you to work with your files. Before you edit a photo, take some time to look over the

menus and toolbars. And, as you begin playing around with some of the editing features in Elements, be sure you're using a *copy* of the photo so that you don't damage the original as you're getting familiar with all that Elements can do.

Now, have those photo files ready, and we'll show you how to work some Elements magic!

You can download a fully functional, free, 30-day trial version of Elements from www.photoshop.com. You can also order a trial CD from the same Web address.

Getting Started with Elements

When you start Elements version 7, you may see the Welcome Screen that provides buttons for the two component programs: Organizer and Editor. Organizer has a Fix tab with basic editing. For what we want to show you in this chapter, however, choose the Edit button to open the Editor program. Notice that both Organizer and Editor provide buttons at the top right for switching to the other program. After you open the Editor program, you have to choose the Edit mode you want to work in. The following sections discuss the various editing options offered by Elements.

Chapter 7 discusses basic editing tools available in most photo editing programs, and Chapter 13 provides an overview of Adobe Photoshop Express, a free, online, photo editing program. For complete coverage of Adobe Photoshop Elements, see *Photoshop Elements 7 For Dummies,* by Barbara Obermeier and Ted Padova (Wiley Publishing).

Choosing your edit mode

Elements organizes functions into three separate modes: Guided Edit, Quick Edit, and Full Edit. The available options and tools are determined by the edit mode you choose. However, the menu commands across the top of the screen remain largely consistent among modes. As is typical with complex software, you'll find options in more than one place in many cases. And don't worry; everyone has to hunt for functions while becoming familiar with a new program.

The edit modes appear as tabs under the Edit tab on the right side of the *workspace*, where your picture appears as you edit. (Be sure to click the Edit tab once to see these modes.) You switch among modes by clicking the appropriate tab. From right to left, these modes are as follows:

- **Guided Edit:** Presents tasks as answers to the question, "What would you like to do?" In Guided Edit, common tasks appear organized under headings (see Figure 8-1). When you choose one of these tasks, your options appear on the right and the photo on the left shows the effect of those options. You can then choose one of the following: Reset, to go back to the previous condition of the photo; Cancel, to cancel the changes you made; or Done, to keep the changes and complete the task.

- **Quick Edit or Quick Fix:** Provides more options and finer control than Guided Edit and with less additional information. Tasks are organized under headings: General Fixes, Lighting, Color, and Sharpen. Figure 8-2 shows the options available to you in Quick Edit mode.

- **Full Edit:** This mode provides the most tools and options with the least guidance from the program. Some of the steps later in this chapter require you to be in Full Edit mode.

 Figure 8-3 shows the options available to you in Full Edit mode, including a toolbar on the left that does not appear in the other modes. (A smaller toolbar appears in Quick Edit mode.)

Figure 8-1: Guided Edit mode leads you through basic editing and more.

Figure 8-2: Quick Edit mode reduces the steps in common tasks.

Figure 8-3: Full Edit mode with a toolbar on the left and Options bar above the workspace (below the menu bar).

You might want to start in Guided Edit mode and explore the options that mode provides. Then, proceed to Quick Edit mode and finally to Full Edit mode. Of course, Full Edit mode offers more tools and options than the other modes, so it's more powerful and may therefore take more time to master.

When you're looking at the task list for each mode, you expand or collapse a heading by clicking the triangle to the left. Expand a heading to show the options under it and collapse the heading to hide its options.

In this chapter, menu commands don't depend on the mode you're in. References to tools and other functions will include the recommended mode. (Some functions appear in more than one mode, although the available options may be different.)

Before we delve deeper into the Editor's functions, we want to at least mention the Fix options in the Organizer (see Figure 8-4). Organizer's Fix options are a little different from those in the Editor. One advantage to Fix is that you can select multiple photos before choosing a fix to apply to all the selected photos simultaneously. Note the buttons at the bottom of the Fix menu that take you directly to the different modes in the Editor. You may want to explore Organizer and its Fix menu on your own.

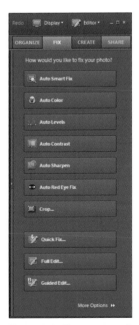

Figure 8-4: The separate Organizer program has a Fix tab you can use instead of using the Fix options in the Editor.

Preparing to edit

Before you can edit, you need to open a photo using File⇨ Open. Browse to select a photo you want to experiment with. When the photo opens, it appears in the workspace, surrounded by the menus and toolbars. Be sure to select the Edit mode you want to start in.

It bears repeating that you should back up your files before you make changes and again after your changes. That's your insurance against any unrecoverable problems, although Elements can undo (and redo) multiple changes. If you're not sure you like what you've done, save your file under a new name to preserve the original.

If you intend to use Elements to edit a lot of photographs, consider some of the options professional editors choose:

- ✔ **Keep your desktop color a neutral gray.** For color correcting, you don't want colors and patterns behind or around your images to influence the way you see those images.

- ✔ **Keep the walls around your monitor as clutter free as possible.** Don't display any wildly colored posters that influence the way you see your images.

- ✔ **Keep the lighting in your work area as consistent as possible.**

- ✔ **Calibrate your monitor.** Try to obtain a screen color as neutral (gray) as possible. You want to standardize your display so that your image-viewing experience is consistent. Windows users can check out Adobe's Gamma utility, although it isn't compatible with Vista. Mac users can use Display Calibrator Assistant. If you're serious about image editing, consider a hardware-and-software calibration package, starting at $75. Check out www. colorvision.com and www.xrite.com.

- ✔ **Establish your color settings (choose Edit⇨Color Settings).** Using the appropriate color settings helps you better manage color among all your devices.

- ✔ **Test your production workflow.** If you'll be posting photos on the Web, view your images in different Web browsers. Print images using different print settings. Find out what works best and how to compensate for any deficiencies in your equipment and methods.

Choosing an image mode

Image modes determine the number of possible colors in an image. For most photos, you want as many colors as possible available for the most accurate color. That would be RGB Color, the image mode you start in automatically (see the following list).

With any photo open, choose Image⇨Mode to see the available modes. Select from one of the following available image modes (you can undo any changes):

- ✔ **RGB Color (recommended):** This mode is the default color mode for Elements and digital photos. RGB Color images can display up to 16.7 million colors.

 Before converting an image from RGB color to another mode, perform all necessary editing. Only RGB images can access all Elements tools and commands.

- ✔ **Indexed Color:** Indexed Color mode supports 256 colors or fewer. The GIF file format uses this mode to prepare graphics for the Web. First, select the Preview option. Choose options for the palette, number of colors (if you want), transparency, and dithering. It isn't vital to know the definition of each setting. This mode is for on-screen images, so simply view the Preview image and experiment.

- ✔ **Grayscale:** Click OK when prompted to discard your color information. This mode converts a color image to a grayscale one. Grayscale images contain 256 brightness levels or levels of gray. Many people would call this color mode black and white, but black and white is just that: one or the other, no shades of gray.

- ✔ **Bitmap:** In Bitmap mode, pixels are either black or white. You must first convert a color image to Grayscale before you can convert it to Bitmap mode. After you choose Bitmap mode, select an output resolution of 72 ppi (Web) or 300 dpi (print). Choose one of these methods from the Use drop-down list: 50% Threshold, Pattern Dither, and Diffusion Dither.

When you open a photo, you will be in RGB mode automatically. That's the mode you want most often. If you plan to print in black and white, change the Image mode to grayscale. (You may never use the other modes.)

Figure 8-5 shows one photo in three of these modes. RGB is generally the best all around.

Photo credit: Purestock

Figure 8-5: RGB color, indexed color, and grayscale images.

Choosing a file format

Most cameras save files as JPEGs (see following list). Some prosumer and DSLRs store files in the RAW format or as TIFFs. You may never need to convert from one file format to another, especially if your originals are JPEGs. However, if you do need to change file formats (to send a RAW file to a friend as a JPEG, for example), Express makes it easy.

You can save your image in any of the file formats described next. To do so, open a photo file by choosing File➪Open and then, to save it in a new format, choose File➪Save As. Next, select from one of the following available file formats from the drop-down Format menu that appears in the Save As dialog box:

- **Photoshop (.psd):** The Elements native file format makes all editing tools and features available. It supports layers, all image modes, and bit depths. Photoshop files are suitable for high-resolution printing. Compare this format with the TIFF format.

- **Photoshop PDF (.pdf):** PDF stands for Portable Document Format, and Adobe developed it for exchanging files: Anyone with Acrobat Reader, a free program that you can download from Adobe, can view PDF files. PDFs support layers and all image modes. They're

suitable for printing and as downloadable documents hosted on Web sites. In the Save Adobe PDF dialog box, specify the Compression and Image Quality settings. Choose High quality for print images, and Low or Medium Low quality for Web images.

✔ **Photo Creation Format (.pse):** This format is used to save multipage Elements projects as a single file. Elements automatically uses this format for multipage projects. (Photos are normally single-page projects.)

✔ **TIFF (.tif):** TIFF, which stands for Tagged Image File Format, supports layers and all image modes. When you select this format and click Save, a dialog box appears in which you specify various options. You can compress these files in a variety of schemes, including LZW and ZIP, which are lossless and therefore do not degrade image quality. Select a byte order (PC or Mac), and leave other options at their defaults. TIFF is an excellent file format for use in illustration and page-layout programs, as well as in Microsoft Word. TIFF images are suitable for high-resolution printing.

✔ **JPEG (.jpg):** JPEG, which stands for Joint Photographic Experts Group, is one of the most popular file formats. JPEGs, which support RGB Color mode, are compressed to reduce file size. The compression scheme they use, however, is *lossy*, which means that data is lost — deliberately tossed. This type of compression can degrade image quality if you repeatedly open and resave images. When you select the JPEG format and click Save, a dialog box appears so that you can choose a Quality value. The value 0 is the lowest quality but has the highest compression (and smallest file size). The value 12 is the highest quality but has the lowest compression (and largest file size). JPEGs do not support layers. Use JPEGs for images to be viewed on the Web and for attaching to e-mail messages. If you want to print an image, use the Photoshop or TIFF file format.

If you must save an image as a JPEG, edit it first and save the original as a Photoshop file. Then save a copy as a JPEG. Return to the Photoshop file to make edits, saving again as a JPEG, as needed. Don't re-edit the JPEG file; doing so compounds the JPEG compression, reducing image quality.

Figure 8-6 shows the JPEG Options dialog box. The quality you choose determines the size of the file.

- ✓ **CompuServe GIF (.gif):** A popular Web file format used mostly for graphics, such as logos, Web buttons, small illustrations, and text. GIFs are small in size but support only Indexed Color mode (256 colors or fewer). If color integrity is important for your Web images, use the PNG format instead.

- ✓ **PNG (.png):** PNG stands for Portable Network Graphics. This format was designed to overcome the color limitations of GIF. As Web browser support of PNG has improved, PNG is slowly replacing GIF for new Web graphics.

Figure 8-6: JPEGs offer a range of quality and compression settings.

The preceding list of file formats represents only the most popular and widely used formats. Elements supports other formats, such as BMP, CT, JPEG 2000, PCX, Photoshop EPS, Photoshop RAW, PICT, Scitex, and Targa. Elements can also open Camera Raw files.

The File➪Save for Web command makes it easy to resize photos for the Web and to compress JPEGs. The dialog box that appears with this command shows before and after versions of your photo.

Editing Basics with Elements

So far in this chapter, we've considered the three Edit modes in Elements and the file formats that Elements works with. In this section, you start to use Elements to edit your photos, including resizing and touching up your photos.

As you open photos, thumbnails of those open photos appear below the workspace in a section called the Project Bin. You can click a thumbnail to switch from one open photo to another.

Resizing the image or the canvas

You can resize a photo using Elements. In most cases, you make photos smaller for e-mail or for posting on the Web. Technically, you can make a photo larger, but odds are it will not scale well and the result will be grainier than the original.

Separately, you can resize the area called the *canvas,* the blank space around the outside of the photo. Initially, the canvas is the same size as the photo you're editing. But Elements lets you increase the size of the canvas to create a frame around the photo. You can also insert text or another photo in this blank space.

It is conceivable, but less likely, that you would reduce the canvas size. However, be aware that the image does not shrink to fit the smaller area. Elements clips the excess image beyond the reduced canvas, effectively cropping the image to fit the reduced canvas.

To resize a photo, follow these steps:

1. **Open any photo.**

2. **Choose Image⇨Resize⇨Image Size.**

3. **In the Image Size dialog box, specify a new width or height using percentages or some unit of measure, such as inches.**

 Normally, you want the Constrain Proportions box checked to avoid distorting your image.

4. **Click OK.**

 Use the Reset button or Edit⇨Undo if you don't like the change.

Figure 8-7 shows the Image Size dialog box and available options.

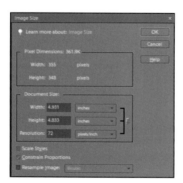

Figure 8-7: The Image Size dialog box.

To resize the canvas around the photo, follow these steps:

1. **Open any photo.**

2. **Choose Image⇨Resize⇨Canvas Size.**

3. **In the Canvas Size dialog box, specify how you want to anchor the image.**

 You can anchor the image in one of the four corners of the canvas, at the top or bottom, or in the middle of any of the four sides. Elements adds the canvas around the image accordingly.

4. **Enter Width and Height values.**

 If the Relative option is checked, the values you enter will be added to the original area. If Relative is not checked, you are entering the absolute size. So, entering 1 inch for width and height adds an inch of blank space around the photo if Relative is checked and reduces the image to 1 square inch if Relative is not checked.

5. **Choose a canvas color from the drop-down list or click the swatch to access the Color Picker to choose a new color.**

6. **Click OK.**

Figure 8-8 shows the Canvas Size options.

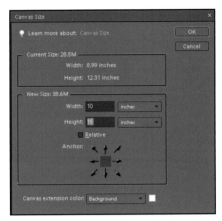

Figure 8-8: Increasing the canvas size around an image.

Figure 8-9 shows an increased canvas around a wedding photo anchored to the center of the canvas, creating a balanced border.

Photo credit: Purestock

Figure 8-9: Add a border by resizing the canvas.

Using the toolbar and Options bar

Generally, you use the menus across the top of the workspace to apply effects to the entire photo. When you intend to apply an effect just to a portion of the photo, however, you use the toolbar along the left side of the workspace.

Although a limited toolbar appears in Quick Edit mode, you most often work in Full Edit mode if you are using the toolbar. Many of the tools in the toolbar *share space*, meaning that one tool is visible, but other tools can take its place. You may not see a tool we refer to later because one of the alternatives is display instead. In most cases, we tell you what those alternatives look like. We also point out keystrokes for using a tool. When the toolbar is visible, the keystroke is usually just a letter. When the toolbar is not visible, the keystroke is usually the same letter plus the Shift key.

The Options bar appears above the workspace and below the menus. The Options bar presents different options depending on the tool you select from the toolbar. However, most of the tools have these options in common:

- **Brush Presets:** Presents a panel of brushes of different sizes, shapes, and styles. Some brushes apply effects in patterns, such as a spray can, an airbrush, watercolor, or a scattered pattern. You can access additional preset libraries from the Brushes pop-up menu. Choose a small brush to start.

- **Size:** Choosing a brush from the Brush Preset also specifies a size. To choose a different brush size, click the downward-pointing arrow to access the Size slider. Drag the slider and specify a size from 1 to 2500 pixels. You can also enter a new number in the box to increase or decrease the brush size.

- **Mode:** In most cases, this is Blend mode, although some tools have other mode options. Blend mode enables application of an effect to select groups of pixels. For example, choosing Lighten from the Blend mode drop-down list lightens the pixels in the area you apply the tool to. There are dozens of blend options. Begin with normal, which is the default.

- **Opacity:** Specify a transparency level or leave it at the default setting of 100 percent. At 100 percent, an effect is

applied completely over the area where you use the selected tool. With smaller percentages, the effect is applied more lightly over the area, and more of the original content appears through the effect you are applying.

✐ **Strength:** Specify the amount of the selected effect that's applied with each stroke. The lower the value, the lighter the effect. You should start with a lower value — you can always increase it later if the effect is too light. (Some tools use Opacity and some use Strength, instead.)

✐ **All Layers:** You use layers to separate parts of an image. We won't go into layers in this chapter, but when you use layers, you have the option to apply effects to the active layer, all layers, visible, or selected layers.

If you need to zoom in for a closer look at the area you're changing, you can choose View➪Zoom In, click the magnifying glass tool, or press Ctrl+=.

Eliminating with the Eraser

You can erase portions of your photo to eliminate defects or distractions. To illustrate this point, see how the upper-right portion of the photo shown in Figure 8-10 has been erased.

Follow these steps to erase an area of your photo:

1. **Choose the Eraser tool from the toolbar. The tool looks like a rubber eraser (or a pink brick) and shares a fly-out menu with the Background Eraser and Magic Eraser tools.**

 You can also press *E* to access the tool. If the Eraser tool isn't visible, press Shift+E.

2. **From the Options bar above the photo, choose from the available options (refer to the bullet list in the preceding section, "Using the toolbar and Options bar," for more details about these options).**

 Note that the Mode option for the Eraser is not the Blend mode used by most of the other tools. Select instead from Brush, Pencil, and Block modes. The Brush and Pencil modes enable you to select any brush preset. Block mode is restricted to a 16 x 6 pixel tip and also doesn't have an Opacity option.

3. In the image, drag over the areas you want to erase.

Because the Eraser tool isn't the most accurate tool for selecting, use the Zoom tool (indicated by the magnifying glass icon) to move in close for a better view. Click in or drag around the areas you want to view more closely. To zoom out, press the Alt key (or Option key on a Mac) and click. (You can also press Ctrl+= to zoom in and Ctrl+- to zoom out.)

Photo credit: Corbis Digital Stock

Figure 8-10: Erase unwanted areas in an image.

Sharpening to improve focus

Most of the time, the subject of your photo will be in focus thanks to your camera's Auto Focus function. Sometimes,

however, the subject or some other area of the photo is not quite as sharp as you'd like. Fortunately, Elements has tools that can help you sharpen particular areas of a picture.

Keep in mind that you can't add focus in Elements if it wasn't there in the first place. By sharpening, you merely create the illusion of focus by increasing the contrast between adjacent pixels. Even Elements can't make a blurry shot clear.

To sharpen the entire photo, choose Enhance⇨Auto Sharpen and leave it up to Elements. You can also choose between two functions that offer a preview of your changes and use sliders to gradually apply adjustments. Choose Enhance⇨Unsharp Mask. (The reason a sharpening tool is called *unsharp* goes back to a darkroom technique.) Or, choose a third technique with Enhance⇨Adjust Sharpness.

With either of these last two tools, make small adjustments and watch the preview.

Odds are, you won't want to sharpen the entire picture, choosing to sharpen the subject or part of the photo instead. To sharpen an area of the photo instead of the entire photo, choose the Full Edit tab.

The edit mode you're in won't affect menu commands such as File⇨Open. However, the full toolbar appears only in Full Edit mode.

From the toolbar down the left side of the screen, choose the Sharpen tool, which looks like a narrow triangle. Many of the tools on the toolbar share space with other tools, meaning you'll see one tool, but you can change that tool into another. The Sharpen tool shares space with the Blur tool (a water droplet) and the Smudge tool (a smudging finger), so you may have to right-click over one of these other tools to choose Sharpen. (Use R or Shift+R to cycle through these three tools.) To apply the Sharpen effect, drag the Sharpen brush over the area you want to sharpen.

Across the top of the workspace, you see the usual Options bar as described earlier in this section.

Always make sharpening the last correction you make. The last thing you want to do is sharpen bad color, artifacts, noise, or nasty flaws. But because sharpening can increase contrast, you may have to redo your lighting adjustments.

Blurring for effect

At the same time you may want to sharpen part of an image, you may also create a better focal point by blurring some part, particularly the background or a distracting element.

Just as you can sharpen the entire photo or just areas of the photo, you can also blur all or part of the photo.

To apply the blur effect to the entire photo, open an image, choose Filter⇨Blur, and choose one of the following blur commands:

- **Average:** Calculates the average value of the pixels in the image and fills the area with that value. Can smooth out noisy areas and obliterate detail.

- **Blur:** Averages the value of the pixels next to the edges of defined areas; applies a fixed, uniform blur to the image.

- **Blur More:** The same as Blur — only more so.

- **Gaussian Blur:** One of the oldest and most commonly used blur filters. Specify a radius for the blur. If a scanned image suffers from a wavy interference pattern called a *moiré pattern*, applying a slight Gaussian blur can help to soften the annoying pattern.

- **Motion Blur:** Gives the appearance of a blur caused by movement. Specify the angle of motion by clicking the circle or typing a value between 0 degrees and 360 degrees. Use the slider or type a value less than 10 (to start) for the distance of the blur in pixels. Select the preview option to see the effect.

- **Radial Blur:** Creates a circular blur effect as if the image were spinning or moving away quickly. Specify the amount of blur. Choose the Spin method. Blur along concentric circular lines or along radial lines (Zoom).

Select a Quality level. Specify where you want the center of the blur by moving the blur thumbnail. Note that radial blur, in particular, is memory intensive and can be slow in rendering.

✓ **Smart Blur:** Has the honor of being the most precise blur command. You specify values for the radius of the area and the threshold. Specify the *radius* (the width of the edges that will be sharpened). For low-resolution images (72 ppi), use a smaller radius, such as .4 pixels. For high-resolution images (300 ppi), use a higher radius, around 1.5 pixels. For the threshold, specify the difference (between 0 and 255) in brightness that must be detected between pixels before the edge is sharpened. A lower value sharpens edges that have little difference in contrast. Set the threshold to 0 unless the image is noisy or grainy. Start with a low value and increase if necessary. Choose a Quality level and a mode setting. Normal blurs the entire image, whereas Edge Only blurs only the edges of the elements and applies black and white in the blurred pixels. Overlay Edge blurs only the edges and applies white to the blurred pixels.

You're better off skipping the one-step filters (Average, Blur, and Blur More). You get better control with Gaussian Blur and Smart Blur for your basic blurring tasks.

To blur a portion of the photo, instead of the entire photo, use the Full Edit mode. From the toolbar down the left side of the screen, choose the Blur tool (a water droplet). This tool shares space with the Sharpen tool (a narrow triangle) and the Smudge tool (a smudging finger), so you may have to right-click over one of these other tools to choose the Blur tool. (Press *R* or Shift+R if the toolbar is not displayed to cycle through these three tools.) To apply the Blur effect, drag the Blur tool over the area you want to blur.

Across the top of the workspace, you see the usual Options bar.

Figure 8-11 shows blurring along the edges of the player that contributes to the sense of motion. (The background blur could be from a shallow depth of field or some other editing effect.)

Figure 8-12 shows a Gaussian blur applied to the area behind the two students to eliminate the distraction of the background.

Photo credit: Image 100 Ltd.

Figure 8-11: Motion blur gives the illusion of movement.

Photo credit: Purestock

Figure 8-12: A Gaussian blur creates a sharper focal point.

Performing Magic or Surgery on Your Photos

Your photo may be in focus and properly exposed with just the right depth of field and composition and still need some major repairs. This section takes you deeper into the magic that Elements makes possible.

Straightening a photo

In a perfect world, your photos look straight without any adjustment. However, if the camera was tilted left or right when you took the picture, the result may be unacceptable. Fortunately, Elements makes it easy to straighten a photo.

In Full Edit mode, select the Straighten tool from the toolbar (the icon looks like a straight frame in front of a crooked frame). You can also press *P* or Shift+P to access the tool.

From the Options bar above the workspace, choose from the following canvas options:

 ✔ **Grow or Shrink Canvas to Fit:** Rotates the image and enlarges or shrinks the size of the canvas to fit the image.

 ✔ **Crop to Remove Background:** Trims off the background canvas around the image.

 ✔ **Crop to Original Size:** Rotates an image without trimming off the background canvas.

Using the Straighten tool, drag a line anywhere in your image to indicate true level horizontal. For example, if you have a picture of a desk or table, you can draw along the top edge of either. As soon as you release the mouse button, the image shifts to make the line you drew horizontal (although the guideline disappears).

Figure 8-13 shows a tilted image. In this case, you could draw your line along the horizon below the setting sun, but the figure shows the line drawn along the bottom edge of the frame. The top edge would work just as well. Whichever you use, your line indicates how much to tilt the picture to make it straight.

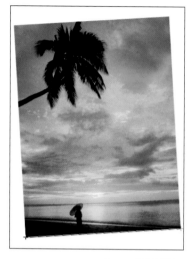

Photo credit: Digital Vision

Figure 8-13: Dragging with the Straighten tool to indicate what should be horizontal.

Figure 8-14 shows the straightened image.

Photo credit: Digital Vision

Figure 8-14: The same image after straightening.

You can also use this tool to tilt an image that is already straight. Doing so with a portrait, for example, gives the picture a jaunty, playful look. Just draw the Straighten tool line across the picture at a slight angle to tip the picture to the side.

Correcting camera distortion

A photo may appear distorted when you shoot a large object, such as a building, close up. Long shots taken with a tele-photo or zoom lens may also show some distortion. Subjects with very strong vertical lines may be more likely to reveal such defects. Distortion may be caused by your position rela-tive to the subject, the angle of the lens, or the lens itself. Figure 8-15 shows distortion of a scene that causes the arch-way and the towers to appear narrower at the top.

Figure 8-16 shows the same scene after using Elements to cor-rect the distortion.

Follow these steps to correct distortion in your photos:

1. **Open an image and choose Filter⇨Correct Camera Distortion.**

2. **In the Correct Camera Distortion dialog box, select the Preview option.**

3. **Specify your correction options:**

 • *Remove Distortion:* Corrects lens barrel distor-tion, in which images look drawn out toward the edges; also corrects *pincushion* distortion, in which images look "pinched-in" at the center. This distortion is sometimes caused by using a telephoto lens. Move the slider and use the grid as your guide for proper alignment for this option (and all the others, too).

 • *Amount (under Vignette):* Adjusts the amount of vignetting (lightening or darkening) around the edges of an image, which is caused by incorrect lens shading, stacking filters, using the wrong lens, and other errors. Change the width of the adjustment by specifying a midpoint value. A lower midpoint value affects more of the image. Then move the Amount slider.

Photo credit: PhotoDisc

Figure 8-15: A distorted image looks pinched or narrow at the top.

- *Vertical Perspective (under Perspective Control):* Corrects the distorted perspective caused by tilting the camera up or down.

- *Horizontal Perspective (under Perspective Control):* Corrects halos and blurs caused by moving the camera. For the best results, specify the angle of movement by using the Angle option.

- *Angle (under Perspective Control):* Rotates the image to compensate for tilting the camera.

Photo credit: PhotoDisc

Figure 8-16: Corrected camera distortion.

- *Scale (under Edge Extension):* Scales an image up or down to crop into the image. Using this option eliminates the "holes" created when blank areas remain on your canvas after you correct the perspective in an image. Be sure that if you scale up, the resolution is high enough to compensate for the increase in dimension, or else you degrade the image.

- *Show Grid:* Shows and hides the alignment grid that helps you make adjustments; you can also specify the grid line color.

- *Zoom:* Zooms your view in and out.

4. Click OK if you're happy with the correction.

If you aren't happy with the results of any edit, choose Edit⇨ Undo. If you can't get back to something you're happy with, don't save the file under the name of the original (if at all).

Enhancing with cloning

Cloning is a tool for repairing small flaws — scratches, bruises, and dings — in otherwise perfect images. With cloning, you select a very small area (even a few pixels) to copy over the area of the photo you're trying to cover up. Be fairly light handed when cloning. If you overwork an area, it ends up looking blotchy. You don't want it to be obvious that an area has been retouched.

Figure 8-17 shows the Cloning tool as a small circle near one edge of the banana. Dragging to the right covers the dark blemishes along the edge with yellow.

Photo credit: www.iStockphoto.com

Figure 8-17: Using the Clone Stamp to cover small imperfections.

Follow these steps to use the Clone Stamp tool:

1. **In Full Edit mode, select the Clone Stamp tool from the toolbar.**

 The stamp looks like a rubber stamp with a handle. You can also press *S* or Shift+S.

2. **From the Options bar above the photo, choose from the available options (refer to the earlier section in this chapter, "Using the toolbar and Options bar," for details about these options).**

 Cloning also has an Aligned option. Select this option to have the clone source move as you move your cursor. To clone from the same source repeatedly, leave this option deselected.

3. **Press the Alt key (or press Option on the Mac) and click the *clone source* (the area of the image you want to clone from).**

 These pixels are copied over the area you select next.

4. **Release the Alt key (or Option on the Mac) and then click or drag in the flawed area (the portion of the image where you want the sampled, or cloned, pixels to appear).**

 When you click or drag, the crosshair is the clone source, and the Clone Stamp cursor is where the cloned pixels are applied. If you select the Aligned option in Step 2, when you move the mouse the crosshair moves as well. If the crosshair is moving, watch it to avoid cloning something you don't want.

 You can use the Cloning Stamp tool for comic or weird effects. For example, placing the clone source area on a person's eye, you can brush a third eye onto the forehead.

Toning with the Dodge and Burn tools

Elements offers two companion tools taken from the film development tradition — dodge and burn — that enable you to lighten and darken areas of a photo to fix exposure. In film development, *dodging* is a technique for decreasing exposure and lightening an area. Similarly, *burning* is a film technique for increasing the exposure and darkening an area.

The Dodge tool (a dark or opaque loupe or paddle), the Burn tool (a hand with the thumb touching the other fingers), and the Sponge tool (a yellow block) share a space on the toolbar. You can right-click over one of these or press O or Shift+O to cycle through them. (The Sponge tool increases or decreases — saturates and desaturates — color in an area.)

Use each of these tools to brush back and forth over an area. As you repeatedly pass over an area, you increase the cumulative effect of the tool on that area. For example, you can use the Dodge tool to remove dark circles from under someone's eyes.

Follow these steps to try out the Dodge and Burn tools:

1. **In Full Edit mode, choose either the Dodge or Burn tool from the toolbar.**

2. **From the Options bar above the photo, choose from the available options (refer to the earlier section in this chapter, "Using the toolbar and Options bar," for details about these options).**

 Besides the general options, Dodge and Burn offer two additional ones:

 - *Range*: Select Shadows to darken or lighten the darker areas of your image. Select Midtones to adjust the middle tones. Select Highlights to make the light areas lighter or darker.

 - *Exposure*: Specify the amount of adjustment you want to apply with each brush stroke by adjusting the slider or entering a percentage. You should start with a lower percentage, such as 10 percent.

3. **Brush over the areas you want to lighten or darken.**

 Take your time between each stroke because sometimes you may experience a slight lag when using the Dodge and Burn tools. If you don't like the effect, choose Edit➪Undo.

Figure 8-18 shows the original, unretouched photo of a close-up of an eye. (Warning: This creeps some people out.)

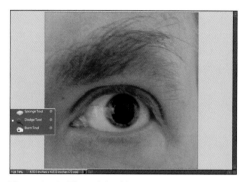

Figure 8-18: The original image.

Figure 8-19 shows the same photo after dodging the area below the eye and burning the right side of the eyebrow.

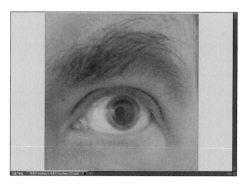

Figure 8-19: After using the Dodge tool below the eye and the Burn tool above it.

Creating New Photos from Old Ones

In addition to fixing or enhancing photos, Elements provides tools, such as the Photomerge command, for creating a new photo out of several existing photos. You can combine separate photos into a panorama or merge individuals into a group shot. You can also create individual photos from a scanned album page or another group of separate photos scanned at one time. (Chapter 10 discusses scanning prints of photos.)

Constructing a panorama

A *panorama* is one large photo stitched together from separate photos of a particular area. A panorama conveys a sweeping vista by showing a wider area than any single photo can. The ultimate panorama is a 360-degree shot that shows the entire area around the photographer. Even a panorama of fewer degrees or a flat panorama of a wide area can be impressive.

You can plan for a panorama when you shoot your pictures. Take several shots, moving the camera steadily between pictures. For example, standing in one spot, shoot, turn to your right until the frame contains the right edge of the previous shot, shoot, and repeat the process, overlapping shots a little. Or, shoot, step to the right or left along a line until the next frame just overlaps the previous, shoot, and repeat. Using a tripod may help you keep a constant level. (A little variation in level or overlap doesn't spoil the panorama.)

Figure 8-20 shows two images in the midst of manual adjustment to a merge. The left image will be merged with the right image, which is the result of merging two other images.

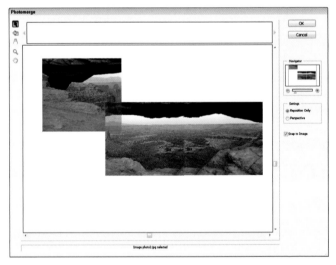

Photo credit: PhotoDisc

Figure 8-20: Manually adjust your source images.

Figure 8-21 shows the resulting merge. This looks like one photo, although it merges three.

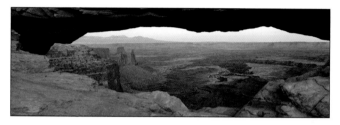

Photo credit: PhotoDisc

Figure 8-21: A panoramic image created by the Photomerge command.

To merge your individual photos into one panorama, follow these steps:

1. **In Full Edit mode, choose File⇨New⇨Photomerge Panorama.**

2. **In the dialog box, select your original source files. Choose From Files or From a Folder from the Use drop-down list.**

3. **Click Add Open Files to use all open files or click Browse and navigate to your files or folder.**

4. **Choose a merge mode in the Layout area from these options:**

 • *Auto:* Elements automatically merges the source files.

 • *Perspective:* You use this mode for images with perspective (or angle).

 • *Cylindrical:* You use this mode for images shot with a wide-angle lens or 360-degree, panoramic images.

 • *Reposition Only:* Elements repositions images without compensating for any distortion.

If you choose any of the preceding modes, Elements opens and automatically stitches together the source files to create a composite panorama in the work area of the dialog box. If Elements alerts you that it can't make the panorama, you will have to stitch the images manually.

- *Interactive Layout:* Elements tries to stitch the images, but you may have to complete the panorama manually.

If you chose the Interactive Layout option, or if Elements failed to merge the images automatically, you must adjust the images manually, as discussed next in Step 5.

5. **(Optional) To adjust the images manually, use the Select Image tool to drag the image thumbnails from the light box area to the work area. Use the Rotate Image tool to rotate the thumbnails. Check the Snap to Image option so that overlapping images snap into place automatically.**

 The Zoom, Move View, and the Navigator view box help you view and navigate.

6. **To adjust the *vanishing point* (the point at which parallel lines seem to converge like train tracks in the distance), select the Perspective option in the Settings area. Click the image with the Set Vanishing Point tool.**

 Elements adjusts the perspective of the panorama. By default, the center image is chosen as the vanishing point. Adjust the other images as needed.

7. **Click OK to apply the photomerge and close the dialog box.**

 Elements opens a new image in the default Photoshop Elements file format (.psd).

Merging group shots

When you take a group photo, consider taking more than one picture. After all, odds are someone has his eyes closed or isn't smiling. Elements has a tool for taking the best parts of several photos and merging them into one photo in which everyone looks good.

To merge multiple photos, open each of the individual photos. They appear at the bottom of the screen in the Project Bin. Then follow these steps:

1. **In Full Edit or Quick Edit mode, choose two or more photos from the Project Bin.**

2. **Choose File⇨New⇨Photomerge Group Shot.**

3. **Take your best group shot and drag it to the Final window.**

4. **Click one other photo to use as the source image.**

5. **With the Pencil tool, draw a line around the parts of the source image you want to merge into your final photo.**

 You can choose to show the pencil strokes or regions, which are highlighted with a blue overlay.

6. **Repeat Steps 4 and 5 on any remaining photos.**

7. **To further align the photos, use the Alignment tool, click the source image, and position the three target markers on the three key locations. Then position the three target markers on the three key locations on the final image.**

8. **Click the Align Photos button. If the image doesn't look satisfactory, click Reset. If you're happy with the result, click Done.**

As with merged panorama images, the better the source images for the perfect group shot, the better the merged image looks. Try to take shots that are similar in framing, size, and exposure.

Figure 8-22 shows the Photomerge Group Shot editing screen. On the left is the source file; on the right is the final version.

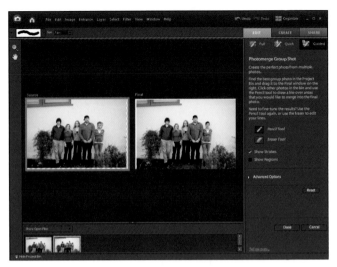

Figure 8-22: Select the elements that you want to merge into the group shot.

Dividing scanned photos

When you scan prints of photos — say, from an old family album — you can scan each photo simultaneously. However, it takes less time to scan as many images as will fit on the scanner glass. It certainly takes less time to scan a photo album if you don't have to remove the photos from the album page. (Test a page to make sure the size of the album or the plastic over the photos won't interfere with the scan.)

Figure 8-23 shows a file created by scanning a photo album page featuring five photos of different sizes.

Figure 8-24 shows four separate files that Elements creates from the scan. Two of the original photos overlapped enough that Elements created a single file out of them. The other three separated perfectly. (A few extra files were created as well. Just don't save anything you don't like.)

Figure 8-23: Saving time by scanning multiple photos at a time, including entire photo album pages.

Figure 8-24: Dividing scanned photos into separate files.

After you have a file created from scanning a group of pictures, you may want to break that up into the individual photos. (See Chapter 10 for a discussion of scanning prints.) Follow these steps:

1. **In either Full Edit or Quick Edit mode, open a file with multiple scanned images.**

2. **Choose Image⇨Divide Scanned Photos. Elements divides the images and places each one in a separate file.**

To get the best results, make sure you have a clear separation between your images on the scanning bed. If your images contain a lot of white area, you may want to cover the images on the scanning bed with a dark piece of paper. Elements uses the background color to identify the edges of each print.

Part IV
Sharing Your Photos

The 5th Wave — By Rich Tennant

"...and here's me with Jessica Alba. And this is me with Beyonce and Heidi Klum..."

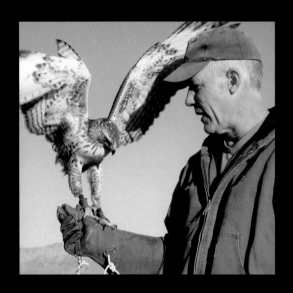

In this part . . .

A photo buried in a folder on a hard drive is no better off than if it were stuck in a shoebox in the back of your closet. Your photos want to be seen. You want people to see them. (Admit it!) E-mail is a great way to share a couple of photos, but not an entire vacation's worth. What other choices do you have? Find out in Chapter 9.

You may not print many of your photos, but there will be some that call for it. Should you print at home or through a service? Chapter 10 provides some insight into this question.

And be sure to look for the bonus section on scanning those pre-digital prints. Now you can embarrass people who thought they were safely distanced from those groovy photos stuck in your family albums.

Sending, Posting, and Copying Photos to Disk

● ●

In This Chapter

▶ E-mailing photos

▶ Posting photos to the Web

▶ Creating CDs and DVDs of your photos

● ●

*T*he more you develop your digital photography skills and the more photos you take, the more likely you'll want to share your photos with family, friends, and associates. You can easily attach a photo to an e-mail message and send that to one person or a group.

To share a lot of your photos, or to share them with a number of different people, you might consider using an online photo-sharing service or even a *blog* (short for weblog), a personal Web site that is simple to create and maintain. And besides e-mailing your photos, you may want to create slide shows that you can burn to a CD, DVD, or flash drive. This chapter tells you how to get started with all of these photo-sharing methods.

Sending Photos by E-Mail

As you've probably figured out by now, digital photography allows for instant gratification:

point, shoot, and view your photo all in a moment. With the widespread use of e-mail, sending a photo to someone else is nearly as instantaneous.

E-mail programs abound. Some are online or Web-based, such as America OnLine (AOL) and Google Mail (Gmail). Other programs store everything on your hard drive, such as Microsoft Outlook or Mozilla Thunderbird.

Most e-mail programs offer one or two options for including images in an e-mail:

✔ Some programs let you insert or paste your photograph directly into the message and control placement and the wrapping of text around that photo.

✔ All e-mail programs let you attach a photo as a file, in which case the message recipient either sees your photo just below the text of the message or has to open the attachment separately. Which way the photo appears depends on the recipient's e-mail program.

The single most important issue in e-mailing photographs is the size of the photo. The larger the file size, the longer it takes to upload, transmit, and download the photo. The larger the image in pixels (width and height), the likelier the recipient is to have some problems viewing the photo. Potential problems vary with the recipient's e-mail program and his or her familiarity with viewing photographs.

The easiest thing for you is to insert or attach your photo as is. For the recipient, that photo may be no problem at all. However, be aware of two common problems for recipients of large photos:

✔ **Display issues:** For inserted images, screen size and resolution differences between your computer and the recipient's may affect the appearance of the inserted image. How much space the image occupies and how the text wraps around the image depends on image size (which you choose) and screen size (which is beyond your control).

In the worst case, the recipient sees a small corner of the image and has to scroll horizontally and vertically to pan over the image or take other steps to view the photo.

Figure 9-1 shows an inserted image that is just too big. This photo of a sunflower should be resized or attached to the e-mail instead of inserted.

Figure 9-1: Images inserted into an e-mail message should be small enough to be seen completely in the message area.

✓ **Dealing with attachments:** If you attach images rather than insert them, your recipient may avoid resolution problems. Some e-mail programs, however, also show attached images within the message itself, just as if they had been inserted, with the same potential for problems as noted in the preceding bullet.

An image that does come through to the recipient as an attachment can pose other problems. The recipient has to save the attached file, find it, and open it successfully. This process can be difficult for users with little e-mail experience or little experience in dealing with attachments.

If you want the recipient to see the full-sized version of a large original — especially if the recipient is planning to print the photo — attach the photo, don't insert it. But for easy on-screen–only viewing, reduce the image size (800 x 600 pixels works for most) and insert the photo into the message. Consider cropping the photo to emphasize the subject and

reduce the size. (See Chapter 7 for some help with cropping and resizing photos.)

Inserting a photo into an e-mail

After you have edited a photo to the size you want and are ready to insert it into your e-mail, follow these steps:

1. **Open your e-mail program. Type as much of the message as you want. (You can add more later.)**

2. **Place the cursor where you want the image.**

3. **Look for a menu item such as Insert⇨Image or a button showing a frame, camera, or tree. Choose the menu command or click the button.**

4. **Browse to the location of the photo and select that file.**

 Alternatively, you may be able to drag and drop the photo from its location into your message. (Dragging and dropping it may serve to attach the file rather than insert it into the message.)

You may be able to drag the image within the message and wrap text to the left or right of the image. Look for wrapping options under Properties for the selected image (right-click the mouse).

Attaching a photo file to an e-mail

When you want to attach an image, or any file, to an e-mail, follow these steps:

1. **Open your e-mail program.**

2. **Compose your message (or do so after these steps).**

3. **Look for the word Attach (or Attach Files), a pull-down File menu with an Attach option, or a paper-clip button that indicates attaching.**

 The action you have to take here to attach a file depends on your e-mail program.

4. **When the Browse box appears, browse to where the photo is stored on your computer and select the file.**

 The name of the file you are attaching should appear above or below the message area.

Your photo organizer or photo editor may offer an e-mail option. That option may also allow you to specify the size of the e-mail attachment. If this option is available, the organizer resizes a copy of the original photo before sending it.

The videos you create with your digital camera are large files. Rather than attach them to e-mail, upload them to a video service and send the link to that site in an e-mail. (See the following section, "Posting Photos Online," to find out more about using online photo services.)

Posting Photos Online

Putting photos on the Web has several advantages over e-mailing photos. You can put more photos on the Web than you can reasonably e-mail to anyone. You can tag your photos for arrangement into virtual albums. And more people can discover your photos on the Web and comment on them.

Many services host online photos, and most offer free account options as well as fee-based accounts that give you additional features or allow you to post a greater number of images.

Some online services are integrated with photo organizers. For example, Google's Picasa photo organizer has online capability, as does Microsoft's Windows Live Photo Gallery. A few photo organizers can be customized to work with more than one photo host.

Hosted photos usually allow for a title, description, and tags to categorize a photo. Some services can read this information from the photo's metadata; all allow manual changes to the text associated with a photo.

The more photos you want to share, the better the choice of a photo host may be for you. Blogs are equally good for posting text and photos online and are discussed in the upcoming section, "Adding photos to a blog."

Uploading to a photo-sharing site

Here are just a few popular photo-sharing sites you may want
to consider, although a number of others are available (try
entering *photo sharing services* into a search engine):

- ✔ www.flickr.com (Yahoo)
- ✔ www.picasa.com (Google)
- ✔ get.live.com (Microsoft)

Web photo hosts require you to create an account, but you
can usually set one up quickly and easily for free. During
account setup, you will choose a username that may become
part of the Web address you give to people to see your
photos, such as www.flickr.com/photos/*mjhinton*.

All photo hosts provide the means to upload one photo at a
time. Many have methods for uploading more photos simulta-
neously using a photo organizer or separate uploading tool.
During uploading, you may be able to limit the viewing of
photos to friends or family, although most photos are freely
visible to anyone on the Web. Just think, digital content from
e-mail and the Web may haunt you decades from now.

Most photo services can optionally resize your photos for
best file size on the Web. Figure 9-2 shows a screen from the
upload process in Flickr. (See Chapter 12 for ten benefits of
using Flickr.)

You can also upload the videos you take with your digital
camera. Flickr accepts short videos (90 seconds or less).
YouTube (Google) is a very popular video host. After post-
ing a video on YouTube, you can send your friends a link to
that video or even embed the video for people to see on a
blog or other Web page.

Adding photos to a blog

A blog (from the term *weblog*) is different from other Web
sites in that the content is generally updated frequently and
the blog entries appear in reverse chronological order —
most recent entries at the top, older as you read down.

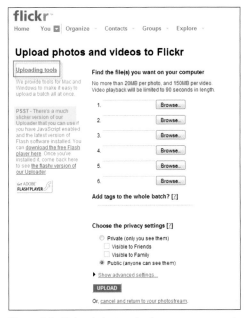

Figure 9-2: Upload photos singly or use a separate process to upload batches of photos.

Blogs can serve almost any purpose. They can be as personal as a diary, or they can help people with a common interest share information or stay in touch. Blogs are even used by corporations to communicate with customers.

Blogs are natural places to post photographs, with or without descriptive text. The photo services in the previous section could be thought of as specialty blogs, displaying your most recently uploaded photos first.

Your photo organizer or your Web photo host may provide tools for uploading (or linking) your photos to blog entries.

Here are three blogging services you might consider using:

- www.wordpress.com is a popular blog host with photo capabilities.

- www.blogger.com is owned by Google, as is Picasa, which can add photos to your blog.

✔ www.live.com is owned by Microsoft. Live.com hosts both photos and blogs, with sharing between them. Windows Live Photo Gallery can upload to the photo service or the blog service (as well as to Flickr or Picasa).

Figure 9-3 shows the image upload dialog box from Blogger. You can browse your computer or specify a Web address for an existing photo (for example, an image on Flickr). The layout options control wrapping of text around the image (if it is small enough). Image size roughly specifies a size — the uploaded copy of the original will be resized automatically.

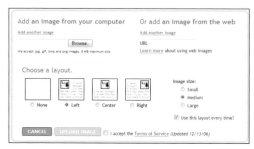

Figure 9-3: Upload images directly to your blog account.

Flickr has a Blog This function that works with each of the blogging services just listed. You upload your photo to Flickr and use the Blog This button to send that photo to your blog account with another service, where the photo becomes part of a new blog entry.

Copying Photos to Removable Media

A computer with an Internet connection replaces the photo albums and slide shows of yesteryear. All you need to enjoy your pictures these days is the Web address of your photo host.

Still, other ways are available to share photos with family and friends. You can copy your pictures to a CD, DVD, or flash drive that you can carry with you or mail to someone else. *Flash drives* are thumb-sized or smaller devices that plug into

a computer's USB port. Copying files to and deleting files from a flash drive is often easier than doing those same tasks on a CD or DVD.

You can arrange the photos you copy (or *burn*) to these types of removable media in several different ways:

✔ As data files

✔ In a slide show

✔ As a video

Which method is better for you depends in part on the effort you want to make in the creation of the disk. Another factor is whether you want the disk to be played on a computer or a DVD player connected to a television.

When you travel with a laptop, take extra cables (USB and RCA) along so that you can hook the laptop to a TV or DVD player for a great way to show your photos. Some DVD players even connect to USB flash drives.

Copying photos to a disk or drive as data

Digital photos are files just like any other electronic data. Consequently, you can copy those files to any disk through the common process of copy and paste or drag and drop.

Most computers can read a CD, DVD, or flash drive created this way. How the photos are displayed by the recipient of this disk or flash drive is really up to him or her. When you drop separate image files to a disk or flash drive, they show up as just a bunch of files — not as a slide show. The viewer decides which pictures to view or skip, and in any order.

You might consider renaming the image files on the disk or flash drive so that when they are viewed as a list, they are also organized in the order you want them viewed (usually chronological). Because filenames are generally listed in alphabetical order, the three files morning.jpg, afternoon.jpg, and evening.jpg are likely to be listed as afternoon, evening, and morning on-screen. But if you rename these files to picture01.jpg (originally,

morning.jpg), picture02.jpg (originally, afternoon.jpg), and picture03.jpg (originally, evening.jpg), they should appear in the order you want them viewed — unless the viewer sorts them differently. Another sorting option is to sort by the time taken. But if you sorted the three pictures in this example in descending order by date and time taken, they would appear in reverse of the order you intended.

Keep in mind that older television DVD players may not be able to read computer data disks. Newer television DVD players are likely to be compatible with newer computer DVD drives. You have the convergence between entertainment and computing industries to thank for that.

Burning photos as a slide show

Rather than simply copy separate image files to a CD, DVD, or flash drive, you can organize your photos into a slide show presentation. Such a slide show can include transitions between photos, including text on or between photos, and you can even play music during the show. But don't panic: These slide shows can actually be easy and fun to create.

The main advantage of a slide show over treating the photos as data files (as discussed in the preceding section) is that you control the order in which the slides are viewed. And you can repeatedly revise this order as you go.

Your computer may have come with software that lets you create slide shows, or the software may be freely available from the provider of your Internet service. If not, your photo organizer or editor may have a slide show feature. (For free slide show software, see the shareware editor at www.irfanview.com.)

Figure 9-4 shows Windows DVD Maker (included with the Home Premium and Ultimate editions of Windows Vista) with Add Items and Duration (how long to keep the image on-screen) circled in red. After you select all the photos you want to include in your slide show, you select a theme for the slide show control menus and for the slide show background. When you are ready, you click the Burn button.

The person viewing the slide show can start, pause, and stop the slide show at will. A separate menu enables the viewer to see individual slides separately from the show.

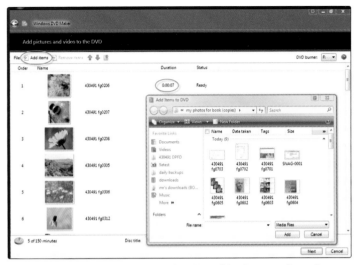

Figure 9-4: Add items and arrange them in a slide show, as shown here with Windows DVD Maker.

Not all television DVD players can execute a computer slide show, which is a computer program, although they may still allow the viewer to pick through the photos.

Creating a photo video

You can also create one single, large video file out of the many individual photos (and video and audio files) you want to share. This video can provide more transitions and special effects than a standard slide show. All the control over what is seen when and for how long rests with the creator of the video. The viewer simply watches.

Slide shows and videos of photos look similar as they play, although one key difference is that a video is a single, large file, whereas a slide show consists of separate files for each photo. Also, video-editing software provides many more effects and transitions than most slide show software.

Your computer may have come with software to create videos out of photos. If not, your photo organizer or editor may provide this feature. (For free video-creation or editing software, see the shareware editor at www.irfanview.com.)

Figure 9-5 shows a video being created using Windows Movie Maker (included with the Home Premium and Ultimate editions of Windows Vista). You can import photos, other images, videos, and music to your video project. You can add transitions between media and effects to each item on the Storyboard, which you can see at the bottom of Figure 9-5.

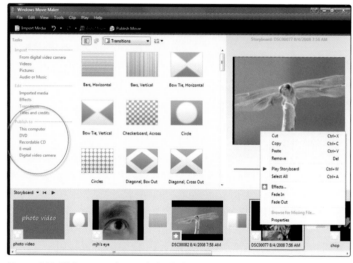

Figure 9-5: Video-creation tools include more transitions and effects than simpler slide shows.

When you're ready, you can publish the video to the computer or to a CD or DVD (see the options circled in red in Figure 9-5). To create a video you intend to copy to a flash drive, use the This Computer option. The software you use may also offer options to specify the quality of the video, which directly affects its file size — better quality means a bigger file. The E-mail option shown in the left pane creates a smaller video file for attaching to e-mail. If you're uploading to a video service, however, you may want to go for better quality and not worry so much about the file size.

10

Printing and Scanning
Your Photos

• •

In This Chapter

▶ Printing your photos
▶ Scanning your prints

• •

*B*ack in the *old* days (maybe six or seven years ago), the
only way to enjoy your photos was to print them. Those
prints were passed around or stored in envelopes (with their
negatives) — often in shoe boxes — until someone found the
time to mount them in photo albums.

These days, the vast majority of digital photos never make it
onto paper — and the forests breathe their thanks. Viewing
photos on-screen gives them an extra brightness. On-screen,
you can sort and re-sort. You can zoom in and pan.
You can edit. You can e-mail and upload. Prints
have none of that flexibility.

Still, a print is an easy way to transport
and share a photo. A large print of a
high-quality photo makes a nice deco-
rative addition to your home or office.

In this chapter, we compare printing
on your own printer with using a
printing service. You also consider
some of the novelty print options.
(Photo mouse pad, anyone?) You can
finally bring those old photo albums to
your desktop.

Using a Personal Printer

Any program that can display a photo can probably also print it. You'll find various print options in different programs. Most will print one photo per page at the maximum print size the photo supports.

How large you can make a print depends on the size of the original image in pixels and the resolution of the print in dots per inch (DPI). Most personal printers print 300 dpi to 1200 dpi. A photo prints smaller at higher resolutions. To see the guidelines for converting image resolution to print size, refer to Table 1-4 in Chapter 1, "Available Image Resolutions."

If you stretch a photo to print larger, the quality drops and the image appears pixilated or jagged. (Don't be afraid to experiment by pushing the limits of this guideline, if it doesn't cost you much.)

Some programs allow you to print different photos to the same page, if they fit. You may also find options in your printing program to print multiple copies of one photo per page.

Before you print a photo, edit it, if necessary, to assure a great print. You may need to adjust brightness, contrast, or color. Consider cropping the photo to emphasize the subject. (Chapters 7 and 8 can help you with editing your pictures.)

Figure 10-1 shows the print dialog box from Windows Photo Gallery, with options for quality, size, paper type, and number of prints per page.

Considering the printer

For personal printing, the choice is typically between laser and inkjet. Color laser printers have traditionally set the standard for excellent quality color printing. And these printers have dropped substantially in price over the last few years, making them much more affordable to the home user. At the same time, inkjet quality has improved, and it's probably safe to say that most home users still purchase inkjets because they can get excellent color print quality for under $100. (Some are substantially less than that.)

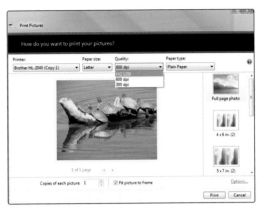

Figure 10-1: Different programs offer different print options.

If you have a black-and-white (B&W) printer, your color photos will print in black and white, of course. You may find the results pleasing or satisfactory. Printing in B&W is always faster and cheaper than printing in color. Even on a color printer, you may want to print in B&W first to test whether the photo has any potential as a print.

Choosing the paper

Regular laser printer or inkjet paper may produce a satisfactory print, depending on what result you're looking for. You can also buy special photo paper made specifically for your printer. It's a good idea to print a test on regular paper before risking your more expensive photo paper.

Using a Printing Service

With a good personal color printer and special photo paper, you can produce excellent prints. However, printing services, including your local drug store or discount store, can print your photos beautifully, cheaply, and quickly. When you compare do-it-yourself printing to using a printing service, doing it yourself may not be worth the effort and cost.

A printing service, such as those provided by Walgreens or Costco, generally offers prints at two standard sizes: 3 x 5 inches or 4 x 6 inches. Prints at these sizes are fairly inexpensive, but you still get high quality.

The higher the resolution of the original photo, the larger you may be able to print in good quality. Test a printing service with a small order of standard prints before ordering large prints.

You can choose to physically travel to a photo printing service (gasp) or you can find one online. With the latter, you post your photos to the online service and either have the prints mailed to you, or you stop by later to pick them up.

Any place that prints photos probably accepts online orders or prints from disk. Ask at the corner drugstore, department store, or neighborhood photo shop.

Before you use a printing service, print your photos on your own printer — keeping in mind that whatever their quality, the service's quality will be better. Test prints will give you a better idea of whether the photo is suitable for printing. Be sure to edit the photo appropriately before you print it.

Prints are usually rectangular. With cropping, your photo could be square. When printed, the image may have white space on either side or, worse, the square may be expanded to fill the rectangle, cutting off two edges of the original photo. Imagine a square photo of a person standing: If her head and feet touch the top and bottom edges of the photo in landscape orientation, there will be added white space on either side; in portrait orientation, her arms may be off the edges. If her arms touch the left and right sides in either portrait or landscape orientation, she may lose her head and feet. Whether the printing service's software or a technician makes the adjustments, be prepared for a cropped photo to be adjusted in the printing process. Even an uncropped original probably has slightly different dimensions (*aspect ratio*) than those of standard prints. This becomes a bigger issue with bigger, more expensive prints. So start with small prints.

Ordering prints from disk

Just before the turn of the century, photo-printing services spread to drugstores and department stores everywhere. Businesses that still print photos are certainly set up to accept a disk from you. In some locations, you'll find an automated kiosk into which you insert your disk.

Your disk should be a CD or DVD, although some services accept flash drives or camera memory cards. Place only the photos you want to print on this disk — anything on the disk that you don't plan to print may result in unwanted prints. Extraneous files also make more work for you to pick and choose your prints.

Copy your photos directly to disk. Do not create a slide show or video from your photos on the disk before trying to print them.

If you want to handle some photos differently — say, make an 8 x 10 print of only one photo — be very clear about the filename of the exception and make sure the service understands. Otherwise, you could end up with 8 x 10 prints of every photo on the disk. You might even consider having two separate disks so that you can keep the custom print separate from all the others.

Ordering prints online

To order prints online, you create an account with an online printing service. Here are a few popular ones to consider (along with local pickup locations):

- ✔ www.costcophotocenter.com (pick up at Costco)
- ✔ www.shutterfly.com (pick up at Target)
- ✔ www.snapfish.com (pick up at Walgreens or Staples)

These are just a few, but you probably have lots of local alternatives such as your local Wal-Mart or Walgreens drugstore.

To order prints through an online service, follow these steps:

1. **Create an account and login.**

2. **Upload your photos using tools provided by the service.**

 Some services upload pictures one at a time, but most allow you to upload many pictures simultaneously.

 Some services can pull your photos from elsewhere on the Web, including from Flickr.com. Recall that the resolution of your photos may have been reduced during uploading to nonprinting services. So for larger prints, upload files directly from your machine.

 Your service may enable further editing of the print after uploading. Ideally, editing isn't necessary because you've already done it. However, if you can preview the print, you may see some problem with the print area that you can fix through editing online.

3. **Select the size and number of prints for each photo. Select other options such as glossy finish or borders.**

4. **Specify delivery method.**

 Some services allow direct pickup or mail delivery; others offer only one of those.

5. **Before confirming your order, review each item in your shopping cart and pay attention to charges for handling, shipping, and tax.**

Figure 10-2 shows the confirmation screen from a series of steps in an online print order.

Many services allow other people to order prints from your photos (with your permission, of course, and at their own expense). You may be able to create an online album for friends and family to access and order their own prints.

Ordering novelty prints

You can print your photos in many other ways. Photos can be printed on almost anything, including mugs, t-shirts, other clothing, even cakes.

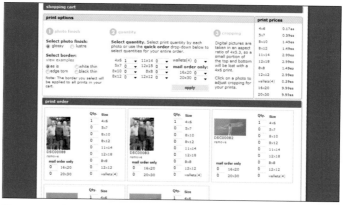

Figure 10-2: Ordering online involves setting up an account and uploading your photos.

You can order high-quality postcards and notecards that showcase your photos. You can even put your photos on postage stamps.

The process of ordering specialty items is very similar to ordering prints online: Find a service, select the product, upload a file, and customize some settings.

Here are a few services that provide options beyond standard prints:

- www.zazzle.com
- www.moo.com
- www.cafepress.com

Figure 10-3 shows part of the process of ordering a photo postage stamp online.

Scanning Prints

The convenience of having photos in digital form to view and share suggests that older prints may find new life in digital form. You can digitize printed material using a *scanner*, a device that *scans* the original and turns it into an electronic file (and people say computer lingo is hard).

Figure 10-3: Stamps, mugs, clothing, and more can bear your photos.

When scanners were invented in the previous century, the developers also (indirectly) created one of the funniest computer acronyms: TWAIN. New scanners were said to be TWAIN-compliant. TWAIN was interpreted to stand for Technology Without An Interesting Name. That's almost as good as PCMCIA: People Can't Memorize Computer Industry Acronyms. (On the contrary.)

We digress . . . to scan your prints to digital format, you need both hardware and software:

- **Hardware:** The scanner is the hardware you connect to your computer, usually by USB. Unless space or portability is an issue, get a *flatbed* scanner large enough to handle the prints you want to scan. A flatbed scanner lets you lay the full image flat on the machine. With a *handheld* scanner, on the other hand, you hold the device in your hand and run it over the piece you are scanning. It may work adequately, but it won't be as convenient or easy to use.

 The scanner has a range of resolution. If you're expecting to view the scans only on-screen, the low end of the range is fine (100 to 300 dpi). High-resolution scans above 1200 dpi produce very large files. This resolution might be desirable if you plan to print a new large print. (In this case, consider carefully photographing the original print instead of scanning it.)

✔ **Software:** Scanning software comes with the scanner, although other software is available. The big issue in scanning printed matter is whether you want the resulting file to be an image or you want the text recognized as text. Clearly, you want image files from your photo prints.

If you want to have one machine that does it all, look into the so-called multifunction or all-in-one printers that include a scanner, color printer, copier, and fax.

Figure 10-4 shows a dialog box from scanning software. Current settings are circled, and the arrow points to the Resolution menu item. You can adjust many settings through menus; you can also adjust the resulting scan file through your photo editor.

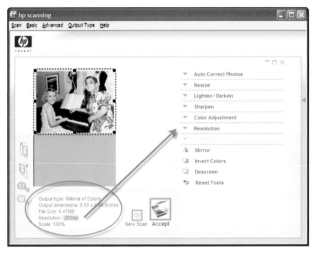

Figure 10-4: Preview a scan and make any adjustments before completing the scan.

Rather than remove photos from album pages, try scanning the entire page, if it fits your scanner. Using your photo editor after the scan, you can crop the individual photos out of the single scan, rotate them as needed, and more.

For photos currently in stacks or envelopes, arrange as many as will fit on the scanner plate, scan them, and then crop the individual photos from the single scan. Scanning a bunch

together and cropping each photo later is usually faster than scanning individual photos.

You can save your scans as JPEGs or TIFFs. JPEGs are smaller and easier to share. TIFFs are larger and may be better for editing or printing. Are you planning to make new prints from old ones? Or is the point of scanning your photos to enable you to switch to the convenience of digital photos? You'll likely find that JPEGs are more convenient than TIFFs.

Upload scans of old family photos to a photo-sharing service to share with the whole family in new digital albums.

Part V
The Part of Tens

The 5th Wave — By Rich Tennant

@RICHTENNANT

NATIONAL TABLOID
PHOTO IMAGING
WORKSHOP

"Remember, your Elvis should appear bald and slightly hunched. Nice Big Foot, Brad. Keep your two-headed animals in the shadows and your alien spacecrafts crisp and defined."

In this part . . .

The Part of Tens is the icing on every *For Dummies* cake, the sweet stuff you can't get enough of. Here are ten tips for taking or making better photographs. Then you can go online to edit and share your photos through Adobe Photoshop Express and Flickr. What are you waiting for?

Ten Tips for Better Photos

● ●

In This Chapter

▶ Getting more out of your camera

▶ Putting more into your pictures

● ●

*B*efore you begin shooting pictures, a few simple steps can ensure that your photos turn out as well as they can. After you've taken the shot, some simple edits can improve it even more. This chapter provides ten easy tips for better photographs.

Know Your Camera

To take pictures, all you really have to know is how to turn the camera on and confirm it is in fully Automatic mode. However, your camera is capable of much more, even if you don't use all of its features. Beyond the topics covered elsewhere in this book, here are a few more features to look for and adjustments you can make on your camera:

- ✔ Turn off digital zoom to avoid pixilation.
- ✔ Turn on image stabilization to avoid blurring.
- ✔ Turn off automatic flash to avoid unexpected flashes that may startle you or your subject. Automatic flash may go off pointlessly in landscapes or when using the zoom.

✔ Use exposure compensation to push a photo lighter or darker.

✔ Use white balance to compensate for fluorescent, incandescent, and other tinted light sources.

✔ Use the histogram display to analyze the distribution of light and dark (and to serve as a guide for exposure compensation).

Become One with Your Camera

The camera does you no good if you leave it somewhere else. Take your camera with you. Don't be afraid to look like a tourist or a camera geek. And the camera does you no good if it's turned off. Have the camera on, lens cap off, and be ready for the next great photo.

Even so, practice discretion. People may not want you to photograph them, so be considerate. Flowers and animals, on the other hand, seldom object. Point your camera down when you're not taking pictures.

Change Your Perspective

Move around as much as you can under the circumstances. Try crouching for shorter or lower subjects. Try holding the camera over your head to clear a crowd. (A tiltable LCD is very helpful in such cases.) Move left and right of the subject to try different angles. You'll discover interesting facets of the subject and new angles on the light. Photograph flowers up close with the light source behind them, but not directly, for interesting color and details.

Take Lots of Pictures

Aside from your initial investment for the camera, digital photos essentially cost you nothing. Go wild. Don't take a few photos, take dozens. Don't come back from vacation with 50 photos; come back with 500. Examine your photos for new ideas or mistakes in composition and exposure.

This liberation comes with an obligation: Don't expect anyone to look at every picture you take, no matter how much they love you. Before you show your photos to friends and family, select the better ones for show and skip (or delete) the less interesting ones. If you have five cool shots of a scene, pick the best, and maybe the second best, to show.

Back Up Your Photos

It should be a given with all digital data that you have a plan for frequent and regular backups. (Odds are you don't. No show of hands here.) There are many different schemes for backup — from full backups of the entire computer to selective backups of individual folders or files. The question is: What will you do when you change your mind about an edit or deletion? Move your files from the camera to the computer and back them up before you begin deleting or editing. Then back them up again after you've carefully organized, edited, and tagged them.

Learn to Edit

You can perform the most basic editing functions with tools you may already have or that you can download from the Web for free. These essential edits include rotating, cropping, and resizing photos. Much more sophisticated editing allows you to tweak individual pixels and completely transform a photo. Start with the basics and move on to fancier tasks when you're ready.

Share and Participate

If you like your photos, someone else will, too. Share your photos a few at a time by e-mail or in larger batches through a Web-based photo sharing site. Give back to your community by looking at other people's photos and commenting appropriately.

Add Metadata

Your camera automatically adds some additional information, called *metadata,* to each photo. This data includes date and time the photo was taken, camera settings used, and camera

model information. Your photo organizer or editor enables you to add tags to describe the photo subject or location. Tag your photos as you copy them to the computer. Use those tags to quickly locate photos regardless of where they're stored or when you took them.

Use a Tripod

A tripod is a must for shooting under low light or with some longer lenses. A tripod is also quite handy for self portraits and group portraits. You may want a full-sized tripod, but everyone needs a pocket-sized version at a minimum.

Add Hardware Extras

Consumer cameras and most prosumer cameras don't take hardware add-ons other than tripods. All DSLRs can change lenses. You'll want a standard wide-angle lens and something for distance, either a fixed telephoto or a zoom lens. Look for lenses guaranteed to fit your particular camera's body.

Some lenses accept filters, which change some aspect of the light, such as tint or brightness. A polarizing filter can reduce reflections from water and glass and add depth to sky blue.

Filters are made for specific lenses. Be certain to match the filter to your particular lens. Most consumer and prosumer models don't accept filters; all DSLR lenses do.

If you use an external, add-on flash, it may accept a diffuser to soften or distribute the light. You can also hold or position a separate reflector — a white or silver panel, oval, or even umbrella-shaped object — to reflect light onto a shaded area of the subject from any side.

12

Ten Benefits of Using Flickr

*F*lickr (owned by Yahoo!) is a very popular photo-sharing service on the Web. You can upload your photos to Flickr to share with family, friends, and the world. This chapter highlights ten features in Flickr that help you organize and share your photos.

Although Flickr is the focus of this chapter, other comparable services are available. Each service has its strengths and weaknesses.

Flickr does not replace photo-organizing software on your computer. You need to be able to find your photos on your own machine. Someday, you may immediately upload your pictures to the Web and never keep a local copy. Until then, organize before you upload. See Chapter 6 for suggestions on organizing your photos.

Setting Up an Account in Flickr

Start by browsing www.flickr.com. If you already have a Yahoo! account, you can use that ID to log in to Flickr by following the

sign in prompts. If you don't have a Yahoo! account, create a free account by following the Sign Up link on the Flickr home page.

Flickr also has Pro accounts, which cost $24.95 per year. Free accounts are limited to the 200 most recent pictures. (When you upload the 201st, the first is no longer shown to visitors, though it is still available to you.) Pro accounts are not limited in the number of pictures you can display. Pro accounts are also ad free. Free accounts have a few other relatively minor limitations.

Start with a free account. If you run into a limit you want to change, you can upgrade to a Pro account easily at any time. (You'll keep the same account information.)

After you set up an account and log in, choose You⇨Your Account and You⇨Your Profile to add more information to your account, such as your interests and location. (If you don't see the You menu item in the upper-left corner of the home screen, you need to sign in using the link in the upper-right corner.)

Uploading Photos to Your Photostream with Flickr

Photostream is the term Flickr uses to describe all your photos. You add photos to your photostream by uploading them from your computer to your Flickr account.

Log in to your account on Flickr. From the menu at the top of the screen, choose You⇨Upload Photos and Videos. On the upload screen, browse for the photos you want to upload. (You can also download a free, easy-to-use tool for uploading batches of photos.) After you select your photos, you can specify tags that will be applied to all photos that are uploaded in one step. You can also specify what kind of access you want to allow: public, private (only you see them), private and visible to friends, or private and visible to family. You identify contacts as friend or family separately.

Figure 12-1 shows the Flash-based uploading screen. The red arrows near the bottom of this image point to links you can use if you want to use a forms-based uploading tool, or if you want to download a tool and install it on your computer.

Figure 12-1: One of Flickr's uploading screens.

Although Flickr's privacy options are good, you should realize that no security is flawless, especially when it's a service whose primary purpose is to share photos with other people. If you want absolute privacy, stay off the Web (or lurk anonymously).

You can add or change your photo's title and description anytime. Click above a photo to change its title and below to change its description. Click the Save button to save your changes or Cancel to reject a change.

Flickr reads some metadata from photos and can use that in the title and tags. Some metadata is recorded automatically by digital cameras. See Chapter 6.

Choosing a Layout in Flickr

Your most recently uploaded photos display first on your Flickr page, and older photos appear farther down and on other pages. This reverse chronological organization of photos is also called a *photo blog*. (Flickr also supports very short video clips.)

You can select a layout for the first page of your photostream (your Flickr home page). From the home page, follow the Change the Layout of This Page link. There are three layout options that use small images, which of course let you put more images on one page, and three layout options that use medium-sized images. Using the larger images lets you display about five photos on the home page. You can also include thumbnail links for your sets or collections.

The medium layouts show off a few pictures nicely. The small layouts show more pictures at one time. (One of the small layouts is used for all pages after your home page.)

Figure 12-2 shows a photo page with smaller thumbnails. Of the six photos in the figure, all have titles above each photo. One does not have a description below it (see the arrow). Circles indicate the You menu item, who is signed in, and views and comment count for one of the photos. Almost every item on this page — all photos and most text — can be clicked for more options or information.

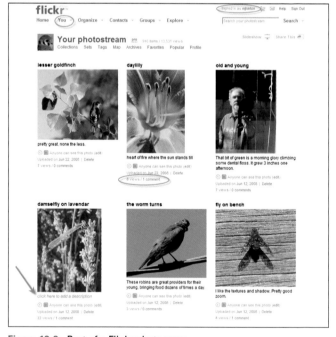

Figure 12-2: Part of a Flickr photo page.

Using Tags with Flickr

During uploading or anytime after, you can tag photos individually or in groups. Tags provide categories for photos. Tags can be unique to you, but many tags are also used by other *Flickrers.* (Okay, we made that up. Flickr members aren't actually called *Flickrers,* but maybe they should be.) You can use tags to search for photos within your account or across all of Flickr. Your tags also create album-like groups. For example, `www.flickr.com/photos/mjhinton/tags/birds/` shows all Mark's (mjhinton's) photos with *birds* as a tag, whereas `www.flickr.com/photos/tags/birds/` shows everyone's photos that are tagged with birds.

To tag a photo after uploading, view the individual photo by clicking it from your photostream. Use the Add a Tag link to the right of the photo. Type a tag in the box (or multiple tags separated by spaces; tags containing spaces must be in quotation marks, such as "my friends"). You can click the link to choose from your tags if you want to use a tag you've used for another photo. To remove a tag from one photo, click the [*x*] next to the tag. Click a tag to see all your photos with that tag or choose You⇨Your Tags.

Figure 12-3 shows an individual photo page with the tags circled on the right. An arrow points from the Add a Tag link to the form that replaces that link when you click it.

It takes a while to get used to tagging photos, and it's fine to change your mind over time about what tags to use. The tags you add to your photos when you use Windows Photo Gallery and some other photo organizers carry over to Flickr automatically.

Organizing Sets and Collections with Flickr

You can add photos to one or more sets during uploading or any time after. Think of a *set* as an album-like grouping. One photo can appear in any number of sets (and have any number of tags, as well). Sets display as thumbnails or larger photos

with titles and descriptions. Free accounts are limited to three sets. Pro accounts can have an unlimited number of sets.

Figure 12-3: Tags appear on the right of individual photos.

To add a photo to a set after uploading, click the Add to Set button above the photo. Click an existing set or click the link to create a new set. To remove a photo from a set, click the [X] next to the set name.

You can give people the Web address for your Flickr photostream or the address of a specific tag or set. Browse the tag or set you want to share and copy the Web address from the address bar into an e-mail message.

Sharing with Flickr

Contacts and groups make Flickr a social network through which you meet people who share an interest in photography

or specific subjects. You don't have to participate in the social aspects of Flickr, but many people enjoy the interaction.

Most photos on Flickr can be viewed by anyone, including nonmembers. You can limit access to photos or the option to comment on photos to Flickr members, to your contacts, or to those contacts you identify as family or friends. You can also keep photos completely private, although that seems to defeat the purpose of a photo-sharing service.

As you explore Flickr, or as people comment on your photos, you can add other Flickr members as contacts (generally, or specifically, as friends or family). Add a contact by viewing a member's Profile (linked to his or her photo pages). Click the Add as a Contact link. (Anyone can decline the invitation to be a contact.) Your contacts appear under the Contacts menu, making it easy to keep up with new photos from contacts.

Any Flickr member can create a *group*. Groups can be open to all or restricted to invitation only. Browse a group and use the link to Join This Group. Be sure to check whether the group has specific requirements (such as that you comment on other photos). Your groups appear under the Group menu. You can contribute your photos to a group by using the Send to Group button on the photo page. To withdraw a photo from a group, click the [*X*] next to the group name on the right side of the individual photo page.

Add comments to other members' pictures and they'll return the favor. You can also mark any picture as a Favorite (use the star above the photo). Commenting and *favoriting* are part of the social aspect of Flickr. Activity in the form of comments and favorites raises a photo's rank and *interestingness*. (Flickr uses lots of words that vex editors.) Flickr automatically displays public photos with a high interestingness rating on its home page.

Keeping Up with Recent Activity on Flickr

When you're logged in, Flickr shows how many times individual photos have been viewed, as well as sets and collections. Choose You⇨Recent Activity to see who has recently

commented or marked any of your photos as favorites. Choose You⇨Stats for details on which of your photos were viewed the most yesterday or for all time, and to get a summary of counts for yesterday, this week, last week, and all time.

The Popular link on your main photostream page ranks your pictures. Photos are ranked by Interesting (calculated from all the other ranks), Views, Favorites, and Comments.

If you don't see certain menus, you may not be logged in, or missing options may be limited to Pro accounts.

Editing with Flickr

From any single photo page, you can click the Edit link. This link opens your photo in Picnik, a Flash-based photo editor. The first time you do this, you have to authorize the connection to Picnik. You may also have to update your version of Flash — but don't worry, it's a freely available program.

Picnik provides editing tools such as Auto-fix, Rotate, Crop, and Resize. Additional options adjust exposure, colors, sharpness, and red-eye. Each of these changes has an Undo and a Redo option.

A separate Create tab adds numerous effects, text, shapes, frames, and more. When you're done editing, choose Save or cancel your changes with the Close Photo link.

Some features are available only with the premium version of Picnik, which at this writing costs $24.95 per year.

Exploring Flickr

Learn more about Flickr, its members, and photographic topics in general by exploring Flickr beyond your own account. From the main menu, the Explore option leads to many options. You should check out the Explore Page, Last 7 Days Interesting (yes, that's an odd phrase), and Popular Tags. That's just to start.

Extending Flickr

One way to get more out of Flickr is to use your Flickr photos in a non-Flickr blog, such as Blogger or WordPress. From a single photo page, you can click the Blog This button. An alternative is to use the All Sizes button on the same screen as Blog This to obtain HTML code for the picture to paste into any Web page.

Many services connect to Flickr, with your permission, enabling you to do more with your photos than Flickr provides. This capability is based on an application program interface (API), a common mechanism for integrating Web-based services. Choose Explore⇨Flickr Services to learn more.

As you look at other people's photos and profiles, you'll discover the services they use.

Ten Uses for Adobe Photoshop Express

* *

In This Chapter

▷ Uploading and downloading your photos

▷ Editing your photos online

▷ Sharing your photos

* *

*A*dobe Photoshop Express is an online photo organizer and editor that you run in your browser, whether you're working in a Windows, Mac, or Linux environment. Express is different from Photoshop Elements, the consumer version of the professional Adobe Photoshop, either of which you buy and install on your computer.

Express has a slick, Flash-based interface for uploading, editing, and sharing your photos. The major disadvantage of Express is the time it takes to upload large photos. Its major advantage is its *editing by example* feature, by which you pick among automatically generated variations of your photo. This chapter highlights ten features of Adobe Photoshop Express that can help you edit, organize, and share your photos.

 Unless you have a very fast Internet connection, a photo editor installed on your computer will be faster and more convenient than one that is Web based. However, Adobe Photoshop Express has features that are worth exploring.

Setting Up an Express Account

Browse the Express Web site at www.photoshop.com/express/ and create a free account. Give some thought to the account name that will appear as part of your Web address, such as http://your-account.photoshop.com. After you create an account, Adobe sends you a confirmation e-mail message containing a link to activate your account.

Uploading Photos with Express

To upload photos, log in to the Web site, choose My Photos (at the top), and click the Upload Photos button. In the Upload dialog box, browse your computer to find the photos you want to upload. You can select multiple photos for uploading simultaneously by pressing the Ctrl key as you select a photo. (Choose just a couple of photos to start. Uploading takes time.)

Figure 13-1 shows the Upload Photos dialog box in front of the My Photos screen.

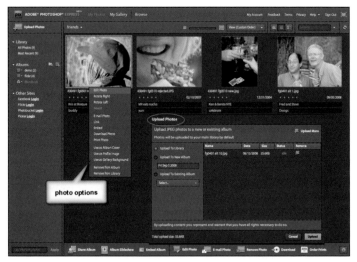

Figure 13-1: The My Photos workspace with the Upload Photos dialog box.

All the photos you upload appear when you choose My
Photos⇨Library. Select a photo if you want to add a caption,
tags, or a star rating.

Using Express for Basic Photo Editing

To edit a photo after uploading, hover your mouse pointer
over the photo. Click Photo Options at the bottom of the
photo. From the pop-up menu, you can rotate the photo right
or left. For other options, choose Edit Photo. Refer to Figure
13-1 for this pop-up menu highlighted as *photo options*.

The Basics menu provides the most frequently used editing
tools. You can crop, rotate, and resize using click and drag.

You can also adjust exposure automatically or manually and
use additional tools to remove red-eye, touch up texture, or
change the color saturation. These editing tools present a
choice among five or so automatically modified images. You
pick the one closest to the change you want.

Multistep undo and redo functions also show separate thumb-
nails of the result of each edit at the bottom of the screen. To
undo or redo an action, click the thumbnail that corresponds
to the edit you want.

Enhancing Your Photos with Express

The Tuning menu offers more advanced options for adjusting
white balance. *White balance* is color shifting based on the
light source used at the time the photo was taken, such as flu-
orescent versus incandescent. You can also highlight the fore-
ground or brighten the background with Fill Light, as well as
sharpen or soften the focus.

Your camera has settings to help you take a perfect picture. You can, however, adjust many of those settings after the fact by using a photo editor. (See Chapters 7 and 8 for more about photo editors.)

Playing with Your Photos in Express

The Effects menu lets you play with color in several ways, including exaggerated tints. You can also switch to black and white and apply a *sketch effect*. Frequently called *posterize*, this effect sometimes looks more like a drawing than a photo. You can even choose the Distort menu item to warp areas of the image you drag your mouse over.

Figure 13-2 shows the edit by example thumbnails above the original photo (labeled Choose edit). The options to undo the last three edits appear as thumbnails below the original. Pick the thumbnail above or below that represents the edit you want.

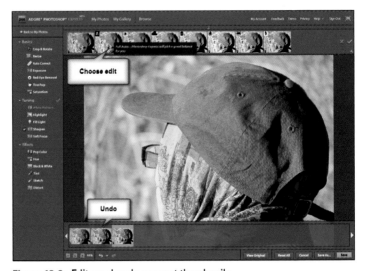

Figure 13-2: Edits and undo present thumbnails.

Downloading from Express

You might wonder why you'd download pictures you uploaded in the first place. When you have finished editing a photo, you may want that edited photo back on your own computer to enjoy, for safe-keeping, or to print. (Express connects to Shutterfly for prints through that service.) To download an image, choose Photo Options⇨Download or click the Download button at the bottom of the screen.

Think twice about overwriting your original photo with the edited version — don't you want both? (That's coming from a real packrat.) Also note that Express renames files that contain spaces and some other characters: Your original *my photo.jpg* comes back as *my_photo.jpg*. This is particularly odd behavior given that the space that was filled in by the underscore worked fine on your computer and for uploading.

Using Express to Share Your Photos

From the My Photos screen, hover over a photo and choose Photo Options. From the pop-up menu, you can e-mail your photo using the e-mail program and address book built into Express.

The Photo Options menu also has options to link to or embed this photo in a Web page (including blogs, of course). Express copies HTML code to your Clipboard for you to paste into a Web page. (The link code is not the complete code for a link, just the Web address.)

Organizing Photos with Express

The Express Library contains all the photos you've uploaded, and you use Albums to organize those photos into groups. The Albums feature includes cover photo and slide show

options. You can give albums a caption or a star rating, and you can add tags.

Choose the New Album button at the bottom of My Photos or the Add an Album button to the right of Albums. Name your new album and then drag photos into your new album from the Library or from other Albums.

For sharing albums, Express has an area, My Gallery, that's separate from My Photos. Albums are marked Private, Private but Available to Friends, and Available to All. You can allow or prohibit printing and downloading of entire albums. You can also view albums as slide shows.

Figure 13-3 shows the My Gallery screen. (The option is high-lighted by an arrow.) Three albums appear. The sharing options for the friends album appear on the upper right.

Figure 13-3: My Gallery shows your albums.

On the My Photos screen, there are options to e-mail, link, and embed albums, just as with individual photos.

Connecting Express to Other Services

Adobe Photoshop Express can connect to other Web services, enabling you to edit photos hosted by those services. If you

already have an account with one of these services, you log in to that service through the My Photos screen. Currently, Express can connect to these services:

- ✔ Facebook
- ✔ Flickr
- ✔ Photobucket
- ✔ Picasa

In effect, you can use a photo-sharing service that has better sharing options than Express and edit those photos with Express, which may have better editing options than the other service. Win-win. (Or Mac-Mac?)

Upgrading to Adobe Photoshop Elements

As we mention at the beginning of this chapter, Express is Adobe's Web-based alternative to two other versions of Photoshop. The granddaddy of them all is Adobe Photoshop, a powerful graphics-editing program used extensively by professionals. You can edit any kind of image in Granddaddy Photoshop, even oil paintings. Photoshop Elements is aimed at people who don't need the full power of Photoshop; this program is geared toward editing photographs. Chapter 8 introduces using Adobe Elements to edit your photos.

You can download a free, 30-day trial version of Adobe Photoshop Elements (or Adobe Photoshop) from www.photoshop.com.

Index

• X •

• Y •

• Z •

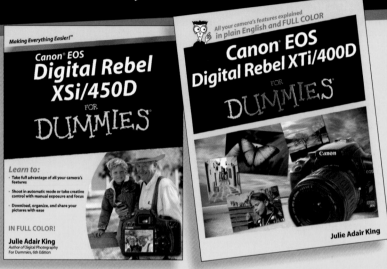